HENRY MOORE:ANIMALS

HENRY MOORE

ANIMALS

TEXT BY W. J. STRACHAN

BERNARD JACOBSON GALLERY/AURUM PRESS

ISBN 0 906053 42 0

Designed by Neil H. Clitheroe
Phototypeset by Tradespools Ltd., Frome, Somerset
Printed in Holland by L. Van Leer & Company Ltd.

Distributed in the U.S.A. by Kampmann & Co.
9 East 40th Street, New York, N.Y. 10016

CONTENTS

PREFACE

With Henry Moore's approval the sculptures and drawings of animals – using the term in its widest sense and including 'animal forms' to embrace reptiles, birds, domestic and wild animals – have been arranged in approximate evolutionary order. Not only did this seem logical, it also fitted neatly with the fact that Moore's first work in this field took the form of drawings and sculptures of snakes and birds.

Two- and three-dimensional examples on each successive theme are shown together irrespective of strict chronology, but his bursts of activity regarding animals are dated and commented on in the latter part of the introduction. Chronology in Moore's production is chiefly interesting in the light it sheds on the modality, the mood of expression, of certain periods of his carving and bronzes and the interplay between them. Sometimes his forms – sketched or sculptured – give hints of what is to come, sometimes they pick up and develop earlier works. This is one of Moore's most individual characteristics.

Imagination and fantasy play such a dominant role in Moore's animal work that the more extravagant examples have been grouped under a heading that, albeit somewhat arbitrarily, sets them apart. However, there is no ambiguity where the artist is drawing from animals observed, such as in the well-known studies of sheep, or from memory combined with other sources as in the case of the wild animals. The so-called 'shut-eye' drawings, based on a student game, reveal an intimate and lesser known, lighter side of Henry Moore's personality. They are a witty corollary to the Fantastic and Fabulous section as well as being an incidental display of pictorial virtuosity.

I should like to thank first Henry Moore for having invited me to fill the gap noted in the extensive literature on his work. It has proved a fascinating undertaking, only made possible with the sculptor's help and many sessions spent with him discussing his animal sculpture and drawings.

The generous cooperation of the Henry Moore Foundation staff and particularly of the two most closely concerned with this work, David Mitchinson and Ann Garrould, not forgetting Betty Tinsley and Jean Askwith who provided documentation at every stage, made it all very much a team enterprise. Angela Dyer of Aurum Press has been an ideal coordinator and editor, and a pleasure to work with.

The Henry Moore Foundation supplied the photographs of Moore's sculptures, drawings and graphics. For those specially taken thanks are due to David Finn, John Hedgecoe, Errol Jackson and Gemma Levine.

Apart from the non-Moore pictures credited on p. 173 some were obtained as the result of a personal gesture on the part of the artist or his representative. Those to whom special thanks are due are Madame Dufet-Bourdelle for sketches by the late Antoine Bourdelle, Madame Jean Lurçat for *Le Bouc et l'Astrapatte*, Mario Avati for *Six Zèbres courant*, Claude Laurens for the Braque relief, John Longstaff of Marlborough Fine Art and Mrs Graham Sutherland for the wash drawing by Graham Sutherland. I would also like to thank Christopher Hodgson and the Dean of Ripon Cathedral in connection with the photographs of the Ripon misericord, and Charles Chadwyck-Healey for the Tostock bench-end carvings. For further non-Moore material I am grateful to the British Museum, the Sainsbury Centre for Visual Arts (University of East Anglia) and the Victoria and Albert Museum for their generous cooperation with photographs and for information contained in their publications.

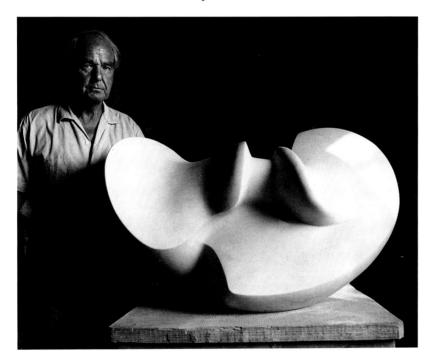

INTRODUCTION

... I can see a lot of connections between animals and human beings and I can get the same kind of feelings from an animal as from the human being. There can be a virility, a dignity or there can be tenderness, vulnerability. I can see animals in anything, really – Henry Moore

Despite the fact that between 1921 and 1982 Henry Moore has made fifty-eight animal sculptures and has drawn many scores of animals – domestic, wild, fantastic – they have not so far received full collective attention. This they certainly merit, since even the smallest sculptures, carved or cast, have a fascinating light to shed both on the various formal treatments the sculptor has adopted in this field over a sixty-year period and on his understanding of animals.

We are not confronted with realistic interpretations – to imitate reality, in the words of the French painter Ozenfant, 'is merely to stuff it' – but with bold, original shapes emphasizing individual animal character. Assertive and varied, the bronzes in particular are in a mode that sets them apart from Moore's sculptures involving the human figure. He chooses animal form because of the uninhibited freedom it allows him. 'People will accept,' he remarked in this connection, 'alterations and distortions in animals quite happily, whereas the same degree of distortion in the human figure would upset them.'

It is not therefore surprising that many of the animal sculptures, especially the animal heads and animal forms, owe more to the imagination than to observation. The psychological and mythological element is omnipresent; often the works seem to be expressions of a release of tension. This differentiates Moore's animal sculptures from those produced by the observers and recorders of animal subjects, of whom Antoine-Louis Barye (1796–1875), who counted Rodin among his pupils, is the most famous, and no less from the Renaissance artists whose interest in animals centred round man. The equestrian portrait, to which we shall return in a later context, shows the horse as a noble extension of the rider's prestige. Although Moore has never ceased to admire the finest manifestations of this classical kind of art, particularly the work of Leonardo and Michelangelo, and steeped himself in its study during his early years, he reacted against it in favour of the art of ancient civilizations and the primitive artefacts he observed in archeological and ethnological museums. Even during his first visit to Italy in 1925 he deliberately devoted his attention to a study of the Italian Primitives – Giotto and Masaccio especially, with their feeling for humanity and breadth of vision. 'At that stage I wanted to know all about the side of art that had been neglected. I wanted to learn about the beginnings.' As we shall see from the illustrations that follow, Moore occasionally returns to a classical idiom in sketchbook and other drawings but, beyond that of theme, these have no connection with the sculptures. The few drawings done with a specific sculptural idea in mind – the sketches for the *Snake* of 1924 (1) and the bronze *Horse* of 1923 (42) – clearly illustrate the new direction in which he was moving.

Drawing for Moore is an obsessive activity embracing studies of form of various kinds, ideas for sculpture, and what may be described as inspired doodles. Even within the limited subject of this book the drawings display such diversity compared with the consistency in his sculptural treatment, that it is necessary to distinguish the main kinds of drawings which here take their place alongside the sculpture under thematic headings.

There are the rapid notations of domestic animals – goats, sheep, cows – made during stays in the country: 'part of my student studies were animals in action'. We see the continuation of this practice in the studies of goats in a notebook dated 1921. The now famous *Sheep Sketchbook* of 1972 has familiarized the public with Moore's superb skill in his more deliberate studies from life of his favourite animal

('Sheep are part of my life'). Affection for and insight into the nature of this creature are implicit in all the drawings, which are mental as well as visual reflections on the various stages of the life of sheep. They are not difficult to appreciate.

Moore's studies of bone form, however, demand an imaginative participation from the viewer, a basic interest in form. They include 'transformation' drawings in which partly invented bone shapes become a pretext for incorporating other figures or objects. Some of the Elephant Skull etchings are based on direct observation, others extract from its convolutions the sculptor's own analogies – caverns and corridors, even a fantastic creature, the Cyclops – that engage our imagination. We marvel at a mind so inventive, a hand so assured.

The kind of drawing grouped under, but not limited to, the heading Fantastic and Fabulous Animals comes closest in spirit to much of the sculpture represented in this book. One might label it 'the alternative vision' – what the mind, perhaps rather the unconscious mind, of the artist discovers and, in Moore's case, uninhibitedly sets down in moments of relaxation or of tension. 'I am conscious of the psychological and associational element in my work,' says Moore. So alongside the fantastic we find also the dark, the horrendous, unambiguously expressed.

Moore's art is far from simple; it incorporates many aspects of both his life and background. First, that of his home, a mining town, grim but friendly, with the Yorkshire moors not too far distant. There among the grazing sheep and outcrops of rock Moore would pick up and study a sheep's skull, the breastbone of a bird. 'Since boyhood I have always been interested in bones.' Not for him as reminders of mortality but because they have once served a function, borne living weight. As for the rocks, they are the bones of the earth, the underlying structure on which the sculptor insists in his interpretations of human and animal form. It therefore comes as no surprise that among his many variations on the reclining form he should have invented a *Reclining Figure: Bone* 1974 (102) carved in Roman travertine – the material that most resembles bone texture. In *Goat's Head* 1952 (54) he celebrates the hardness of bone, its knobbiness; in *Standing Figure: Knife Edge* 1961 (100) the fineness of bone combined with tensile strength; whilst in his Elephant Skull etchings he explores its structural miracles.

Moore's sculpture continually reminds us of growth and pressure from within: in the animal heads, for example, of the skull beneath. It

is interesting to compare this emphasis on bone with that on musculature in the modelling of Rodin. But the roundnesses are of paramount importance in Moore's monumental *Sheep Piece* 1971–2 (71) which evokes the contours of the mountain in the Lake District aptly named 'Wetherlam'. 'A woman and a mountain', asserted Rodin, 'are constructed in the same way, in accordance with the same principles.'

Moore's name is linked in our minds with the Querceta quarries in Italy, where four centuries earlier his great predecessor Michelangelo, under the shadow of the mountain Altissimo, had obtained the marble for the *Moses* that so impressed Moore in his childhood. In close proximity to this, having acquired a small villa at nearby Forte dei Marmi, Moore passed two summer months each year relaxing with his wife and daughter, but also spending many hours with the help of Italian carvers, producing such works as *Divided Oval: Butterfly* 1967 (33) and *Butterfly* 1977 (35).

With the skilled help of his assistants Moore has over the years been able to see his small maquettes scaled up, and cast in bronze to the size he wants. The relevance of this fact here is that the general public, not just museum and gallery visitors, have become familiar with his large works, of which there are no fewer than forty-two in the open air on permanent sites in Britain. Most of these are in a figurative human idiom. Familiarity – in sculpture at least – breeds respect. As the late Herbert Read observed apropos Moore's *Three Standing Figures* of 1948, which was not received with enthusiasm in some quarters, 'Good sculpture in the end subdues the spectator.' Unlike the sculptures mentioned, the animal pieces are not yet widely known and for this reason present an element of surprise. The early ones, being mostly small carvings (between 1920 and 1940 nine-tenths of Moore's output were carvings) escaped notice or passed into private ownership. Even more recently their appearance in exhibitions of Moore's work has been numerically modest. From this point of view the Madrid exhibition in 1981 was exceptional: twenty-five of the fifty-eight animal sculptures illustrated in this book were on display. It should be added, however, that ten of the twenty-five belong to the last decade of Moore's work, representing a period of some intensity in both animal drawing and sculpture.

It would be foolish to exaggerate the role of animal sculptures in relation to the vast corpus of Moore's work related to the human figure. Rather should we emphasize their individuality, their language

of asides, of intimacy, where smallness can be an advantage. Expression is crystallized, concentrated into a few square inches of carved wood or stone.

Whatever influences can be detected in Moore's early work, such sculptures as *Dog* 1922 (79) and *Snake* 1924 (1) already bear the mark of an outstanding talent, announce a new sculptural identity. Like the Minerva of his *Prométhée*,* Moore seems to have sprung up into the world of three dimensions, fully armed.

As for scale, Moore has observed, 'a small sculpture only three or four inches big can have about it a monumental scale so that if you photographed it against a blank wall it might seem to be any size.' His experience of primitive and exotic artefacts on his frequent visits to the British Museum had shown him that they could be diminutive and yet abound in vitality.

We know the part that the study and assimilation of influences played in Moore's formative years. The extent to which he transformed them into a highly personal language, already displaying his genius, was plain to see in an exhibition of early Henry Moore carvings of 1920 to 1940 held at Leeds City Art Gallery in 1982.

There is a negative and positive side to the development of any artist worth his salt. Good art implies refusal – in Moore's case, rejection of the academic tradition in which he had been nurtured. One teacher at the Royal College of Art thought Moore was showing 'insufficient regard for tradition'. He had learnt the technical side of carving and astonished his teachers by carving 'direct' in marble – that is without the aid of a pointing-machine but solely by eye – the head of a Madonna by Domenico Rosselli. He had decided against subject and symbolic sculpture, which he felt had run its course; Rodin had used the human form to the ultimate point of expressivity. For Moore sculpture was to be a springboard for the imagination, a pretext for explorations of form: 'Sculpture must have its own life.' It was in the sculpture of ancient civilizations – early Greek, ancient Egyptian, Aztec, primitive tribal artefacts – that Moore found the energy of expression that corresponded to his own innate feeling about sculpture. This does not mean that he neglected traditional classical art. 'No one really knows anything unless he also knows the opposite' – on which for the moment, deliberately and creatively, Moore had turned his back.

* *Prométhée*, a dramatic fragment by Goethe, translated into French by André Gide, illustrated with colour lithographs by Moore in 1950–51.

Moore has a deep respect not only for the smaller sculpture but for such works on the grand scale as the Greek *Lion* carving illustrated here: 'This colossal sculpture really conveys the serene majesty of the king of the jungle. His face is marvellous, that nose is almost breathing.' The sculptor had not been content merely to represent the details of form; the whole work is a synthesis. The mane, for example, is severely stylized, but, as Moore points out, the animal is alive in all its vastness. To juxtapose a bronze a mere 48 centimetres high is to make a contrast not of scale but of attitude. Barye's bronze *Lion killing a snake* is a realistic portrayal of action. Barye worked in the Paris Zoo, Le Jardin des Plantes, where he organized an art school. He drew and modelled from the wild animals around him, imagining them in dramatic situations. The bronze, particularly the detail reproduced here, has a further relevance since we can also compare Moore's several versions of the reptile that seems to have fascinated him (pp. 26–30). Moore's snakes illustrate his tenet that you do not have to represent movement to evoke emotion. What strikes one about Moore's *Rearing Horse* 1959 (44), however, is not the actual simulation of movement but that the act of rearing expresses one aspect of equine behaviour – nervousness, propensity to panic. It is conveyed by shape. There is animation in the smallest of his animal sculptures, whether reptile, bird, horse or animal form.

Capturing movement in drawing is a different matter. It can – as in the 1921/22 Notebook – be conveyed by synthesis, a mode of expression which might have been inspired by a work such as that of the Scythian bronze he drew at a later date (40). Moore's enthusiasm for the art of the remoter past and the primitive had been fired in his days as a student in Leeds by visits to the collection of Sir Michael Sadler which also embraced works by modern pioneers, notably Gauguin and Picasso. (Gauguin's first-hand experience of primitive art was aptly summed up in his '*C'est sauvage, mais c'est de l'art!*') Other influences on Moore's development were his reading of Roger Fry's *Vision and Design* and Ezra Pound's Memoir on Gaudier-Brzeska, whose sculpture and drawings, especially of animals, Moore greatly admired.

Any description of Moore's early carving must include some account of the work and influence of the great pioneer of modern sculpture, Brancusi. First, because of his revival of direct carving which had not been practised in Europe for centuries. An indefatigable evangelist, he went round proclaiming his new gospel: '*La taille*,

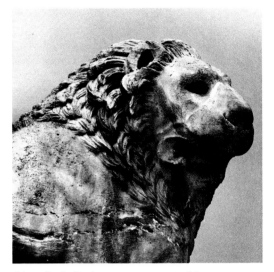

Lion 3rd–2nd century BC, marble
A carving originally on a tomb near Cnidos, south-west Asia Minor

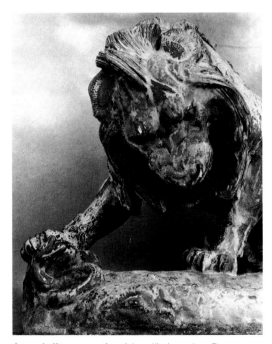

Lion killing a snake (detail) Antoine Barye (undated) bronze

c'est la victoire!' (carving is victory). His early career presents parallels with Moore's. He found the academic training at the Bucharest School of Art utterly dull and uninspiring; the sole recognition awarded to his talent was a medal, third-class, for anatomy. Yet – and one thinks of Moore and the Rosselli Head – Brancusi's copy of the classical sculpture *Antinous Flayed,*[*] executed by him in 1902, was to serve for teaching anatomy in the same school for the next fifty years.

Brancusi too had learnt the lesson of refusal. In response to Rodin's invitation that Brancusi should work for him in his studio, he replied 'You cannot grow under the shadow of a great tree.' It implies what Moore meant when many years later he said, 'If artists don't make a change, they're doing nothing.' An important corollary to Brancusi's principle of direct carving was that of 'truth to material' to which Moore initially subscribed, but finally rejected. 'To begin with I thought something in stone was *ipso facto* intrinsically a better work of art because it was in stone . . .' Moore soon realized that the synthetic simplification that Brancusi preached and practised would be a limiting factor in his own development and he declared Brancusi's obsession with the egg or ovoid form 'too one-cylindered'.[†] However Brancusi's carving *Leda* (p. 40) makes an interesting comparison with Moore's *Duck* of 1927 (17). Both are successful syntheses of form. To this language of synthesis Moore added certain elements of cubism, notably in the *Dog* 1922 (79) and *Snake* 1924 (1) which he adapted to his own personal vocabulary. The 'squareness' of the former is a feature that was to recur in many later Moore works; it is a marked feature of *Slow Form: Tortoise* (8). 'I have always had a fondness for squareness,' says Moore.

'Good sculpture', according to the Austrian sculptor Wotruba, 'should combine barbarism with culture.' He could have had in mind the work of Brancusi, Lipchitz (see *Figure*, p. 51), Picasso and other pioneers of modern sculpture influenced by primitive expressionism. It certainly applies to Moore's animal heads and animal forms, but this element represents only one of the many that Moore successfully assimilated.

Of all the sculpture of the past, the most influential on Moore's own direction has been the Aztec stone sculpture of Mexico. Its 'stoniness'

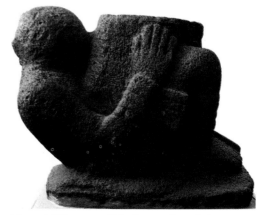

Vessel (Chacmool) in form of reclining man
Mexico, 14th–15th century, stone

[*] A sculpture showing an *'écorché'*, a flayed body, used to demonstrate anatomy in academy schools from the Renaissance on.

[†] Brancusi's fanaticism about form led to him putting up a warning in his studio: 'N'*entrez pas si vous n'êtes pas géomètre*'!

appeals to him: 'Mexican sculptures have a cruel hardness that is the opposite of other qualities I like in European art.' Everyone who knows Moore's early Reclining Figures, such as that carved in Brown Hornton stone (1928), is aware of the sculptor's debt to the Chacmool Aztec carving which inspired it. As Moore reminded me, this symbolic figure – as he discovered on his visit to Mexico in 1953 – is as ubiquitous there as the crucifix is in Christian countries. Not all the Chacmool carvings are on a large scale, nor are many Inca-style artefacts such as the lively, almost toylike *Llama* illustrated here. Symmetry, however admirable in such diminutive sculptures, has the disadvantage of limiting views to one aspect. Moore found the multiplicity of view that he favours in other pre-Columbian carvings, such as the *Plumed Serpent* carved in basalt which was illustrated next to his own alabaster *Snake* in the Mexican exhibition catalogue of 1982.

During one of my conversations with Moore, as we considered other animal portrayals of the past, Moore was attracted by the *Bird's head with serpentine tail* of Scythian origin – a masterly summing-up of the essence of both creatures in a tiny gold ornament. Ancient Egyptian carvings combine stylization with natural observation, as illustrated in the *Head of a Cow* (p. 90), carved in alabaster. This animal, deified through its association with Hathor, the protectress of women, has been carved with evident affection . Moore commented: 'the sculptor has perfectly captured the soft docility of the young cow. The Egyptians had a great feeling for animals, and this is one I love.' In view of the tenderness with which Moore has drawn sheep, one is not surprised that he also admires the *Head of a Ewe* executed in baked clay five thousand years ago.

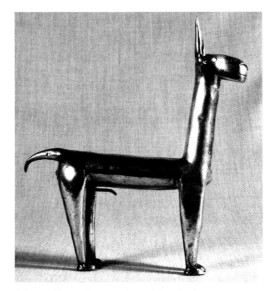

Llama Peru, Inca style, 12th–14th century, silver

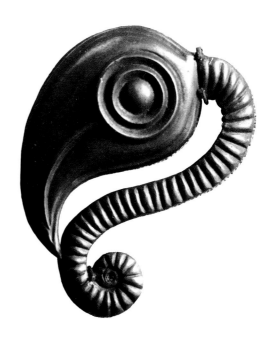

Bird's head with serpentine tail Scythian, 5th–4th century BC, gold

Head of a Ewe Sumarian, from Babylonia. late prehistoric period *c.* 2900 BC

Retreating still further into the paleolithic period we turned to the animal portrayals on the walls of the Lascaux caves in the Dordogne region of France, which we had both seen after their chance discovery in 1940. From the noblest but as yet untamed horse, the *bovidés* – bulls and bisons – to an imaginary prototype of the unicorn (some form of rhinoceros) and the pony-like horses, they drew from Moore the comment 'marvellous!'. The weight and volume contained within the black contours, the application of the earth pigments – red, yellow, brown – on these huge representations are a dazzling revelation of the skill of *homo ludens: homo sapiens* extending his necessary activities into art as play. Here we have man depicting with respect and admiration the animals that he needs for food (we see a bison transfixed with arrows) or uses for religious sacrifice. The dichotomy should not surprise us: it has long been a feature of man's attitude to animals. In Pisanello's painting *The Legend of St Eustace* (in the National Gallery, London) the future saint, seeing the cross of Christ rise between the stag's horns, ceases his pursuit, only later to be proclaimed, ironically, the patron saint of the hunt.

The horse, tamed by man for the chase and for battle, has because of its beauty of form attracted artists through the ages. The treatment of the horse in the many equestrian portraits of the Renaissance, however, appeals less to Moore than the style exemplified in the bronze statuette *Horse with armed rider* in the British Museum. This has nothing in common with the Greek reliefs of cavalrymen from the Parthenon which we can now see in the same museum, nor does its head bear any resemblance to the famous *Helios* horse – the prototype of the Renaissance horse's head, from Donatello's *Gattamelata* to Antoine Bourdelle's *General Alvear* in our own century. The squareness of the horse's head, with its effective plane ridge, echoes the form of the rider. 'I love the vitality and alertness of this piece,' states Moore. 'You feel that the horse could turn its head at any moment. I also like the way the tail comes back towards the feet, to keep the unity of the piece' – a compositional device that Moore himself adopted in his bronze *Horse* of 1959 (45).

Most British readers will be familiar with the Iron Age horse carved in the chalk of the hills near Uffington. It is an outstanding example of reduction almost to an ideogram. The long curve of the back, the scimitar-like rear legs, the thin, prancing forequarters produce a work far more telling than any descriptive portrayal.

Much of Moore's animal sculpture and drawing takes similar

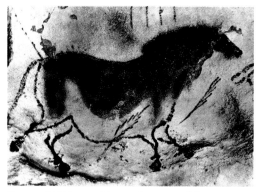

Second Chinese Horse Lascaux, Upper Paleolithic *c.* 20,000 BC

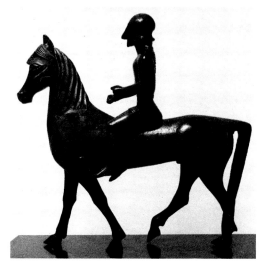

Horse with armed rider Greek workmanship in southern Italy, *c.* 550 BC, bronze

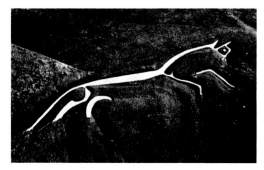

Chalk Horse Uffington, Oxfordshire, Iron Age *c.* 550 BC, chalk carving

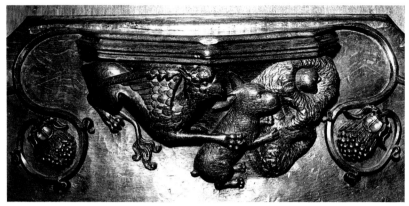

liberties with reality. He produces his own zoomorphic animals. Unlike his medieval predecessors he has needed neither mythology nor legend for pretext. We should not, however, follow him into his Fabulous and Fantastic world without a brief word about the kind of carving he admired in eleventh-century Yorkshire churches and wood carvings of a later date on bench-end and misericord. Here the wyverns and griffins of pagan myth are juxtaposed with Christian symbols. The real animal and the fabulous are ingeniously combined in, for example, a misericord in Ripon Cathedral in Moore's own native county. A griffin is chasing a rabbit as the latter bolts for its hole.* The surrealist element is often present: on a carved capital in Canterbury Cathedral crypt goats are portrayed playing musical instruments.

Moore's fantasy is more in tune with that of his contemporary, Miró. Expressions, sometimes light-hearted, sometimes horrendous, that emerge from Moore's private world suggest the workings of the unconscious. But there is always, too, the exploitation of the accidental. Moore quoted Leonardo in this connection: 'Every artist should be capable of turning a lichen mark on a wall into a picture.' This does not, however, explain away the significance of many of Moore's graphic fantasies. A passage from Samuel Butler's Notebooks seems to me to throw light on creations that puzzle our rational mind. 'An artist's touches are sometimes no more articulate than the barking of a dog who would call attention to something without knowing exactly what it is. This is as it should be, and he is a great artist who can be depended on not to bark at nothing.' I thought of this as I

* There is good evidence, since Lewis Carroll's father was a canon of Ripon Cathedral to which Carroll paid frequent visits that the opening of *Alice in Wonderland* was inspired by this carving.

Griffin chasing rabbit Misericord, Ripon Cathedral

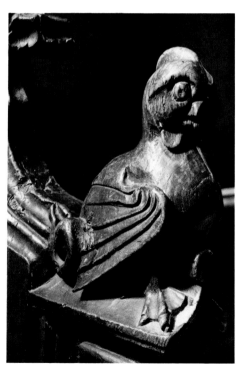

Wyvern Bench end, Stowlangtoft Church, Suffolk, mid-16th century

looked at Moore's interpretation of Dürer's *Portrait of Conrad Verkell*. Not content with the initial interpretation with its own emphases, Moore sketched below a 'transformation' of Verkell's main feature – turned his hooked nose into a hill and set it on a horizontal plane with a fantasy-landscape of distant trees. A less striking but amusing 'transformation' occurs in a notebook of 1926 with figures described in pencil as 'mother and child seated on a half-sphere' (134). With a few strokes the half-sphere has become the hindquarters of an animal with a calf's head. This playful element often occurs in strange, ambiguous forms, as we shall see under the heading Fabulous and Fantastic.

The periods of special activity concerning animals in Moore's work should be viewed against a background of relevant events in his life and sculptural landmarks. In the sixty-one years from 1921 to 1982 he produced, during thirty-three of them, at least one animal sculpture a year, and often several. There are periods of particular intensity – relative to his other major sculptural commitments – in the genre. Between 1921 and 1924 three of the four pieces are carvings. The year 1927 is marked by the production of a bronze *Bird* (15), a carving, *Head of Serpent* (3) and a cast in concrete, *Duck* (17). The bronzes, the *Horse* of 1923 (42) in particular, are rich in curved forms, while the pieces just mentioned and also the *Dog* (79) show a cubist influence. *Snake* (1) is strongly geometricized, but in the *Serpent* of 1927 we detect a surrealist element which became more pronounced in the carved *Bird and Egg* of 1934 (19). Moore was in fact on the committee of the International Surrealist Exhibition held at the new Burlington Galleries in London in 1936. He had already met Giacometti, a pioneer of the surrealist movement (creator of the classic *The Palace at 4.00 am*) and Jacques Lipchitz. But in keeping with his strong individualism, he never entered fully into the surrealist movement. 'I was never a fully paid-up member,' he confessed with a smile. Not that there is any lack of the irrational element in Moore's work. Indeed, it is a marked feature of most of the animal bronzes and animal forms. 'All good art has contained both abstract and surrealist elements ... intellect and imagination, the conscious and the unconscious.' In 1937 he had made a more specific statement: 'My sculpture is becoming less representational, less an outward visual copy, and so what some people would call more abstract; but only because I believe that in this way I can present the human, psychological content of my work with the greatest directness and intensity.'

Moore's surrealism, then, owes nothing to manifestos and everything to his individual exploration of ideas. The *Bird Basket* of 1939 (12), for example, illustrates this point. The latter was followed by the longest gap in his production of animal pieces, extending up to 1951, the year of the first animal head. The Second World War had interrupted Moore's sculptural activities but his Shelter Sketchbooks brought general recognition of his drawings for the first time, and the *Madonna and Child* 1943–4 carving for St Matthew's Church, Northampton, did the same for his sculpture.

Five years later, in 1948, Moore's carving *Three Standing Figures* was sited (permanently as it turned out) in Battersea Park for the first open-air sculpture exhibition of its kind in the world. The same year saw him the winner of the International Prize for Sculpture at the XXIVth Venice Biennale. In 1951, the year of the Festival of Britain, the first Moore retrospective exhibition was held at the Tate Gallery. More relevant to the present book, however, is the publication in 1957 of an album entitled *Heads, Figures, Ideas* by the New York Graphic Society and the casting of Moore's *Atom Piece* (106) in 1965, with its head shaped like the top of a skull. Of the period from 1965 onwards, which included his regular stays in Forte dei Marmi, he said: 'Now that I am carving again, it is natural that the carvings I did between 1920 and 1940 . . . influenced the work I am doing now. So, in carving, I am picking up where I left off.' These later carvings naturally reveal a new breadth of treatment and an even stronger individuality. This is evident in two examples illustrated here, *Divided Oval: Butterfly* (33) and *Butterfly* (35). Similarly, years of experience separate the Snakes and Serpents of 1924 and 1927 from the complex, asymmetrical *Animal Form* of 1969 (95) – a development of *Large Slow Form* (9) and *Animal Carving* (92) in rosa aurora marble, a refined synthesis of form that only Moore could have devised.

Taken together these fifty carvings and bronzes constitute a remarkable testimony to a hitherto insufficiently known aspect of Moore's inventive genius. If, as they should, they tell us more about the sculptor than the animals, we can turn to his drawings and graphics – some of which, admittedly, are as mysterious as a number of the sculptures, but others, particularly the sheep series and those of wild animals, more descriptive – for a study of Moore's relationship with the animal world.

Moore has long worked in various autographic media, although his preferred medium is etching. In this he has become an expert,

sometimes combining the process with drypoint, aquatint and soft-ground, occasionally with the addition of colour. More important, Moore's genius as a draughtsman has enabled him to extract from the etching medium, as from lithography, its full expressive potential. Like other great masters of etching – from Rembrandt to Dunoyer de Segonzac and Picasso – he draws directly on to the prepared copper plate.

Moore is a compulsive draughtsman. A day never passes without him spending some time drawing in his graphics studio, using, as the reader will see from the captions, a great variety of instruments – 'whatever comes to hand', from ballpoint, felt-tip, conté crayon for line, to charcoal, watercolour wash, wax crayon, gouache for tone – in every possible combination. Apart from their merit as drawings they reveal Moore, once again, as an inveterate experimenter.

1 REPTILES

Sculpture makes its impact basically through shape – Henry Moore

Even in civilizations where the snake is regarded as sacred, it does not feature widely in three-dimensional representations, perhaps because its sinuous form does not lend itself to sculptural treatment. When it does occur, it is mainly for what Moore calls 'symbolic or associational' reasons. The obvious example in the West is the serpent in the Garden of Eden, which is largely responsible for the loathing which the snake and its image provoked in times when the Bible was more literally interpreted than it is today. However, an irrational hostility towards the species lingers on, unforgettably voiced by D. H. Lawrence in his poem 'The Snake' – 'And the voice of my education said to me "He must be killed"', with the final contrition, 'And I have something to expiate/A pettiness.' In Greek mythology we have not only the legend of Laocoön crushed to death by two serpents but the fearful Medusa with her hair composed of writhing snakes. For the most sympathetic attitude to the snake we have to go to the Far East and look at a marvellous brush drawing of its fluid form by Utamaro.

The snake makes rare appearances in medieval carving in this

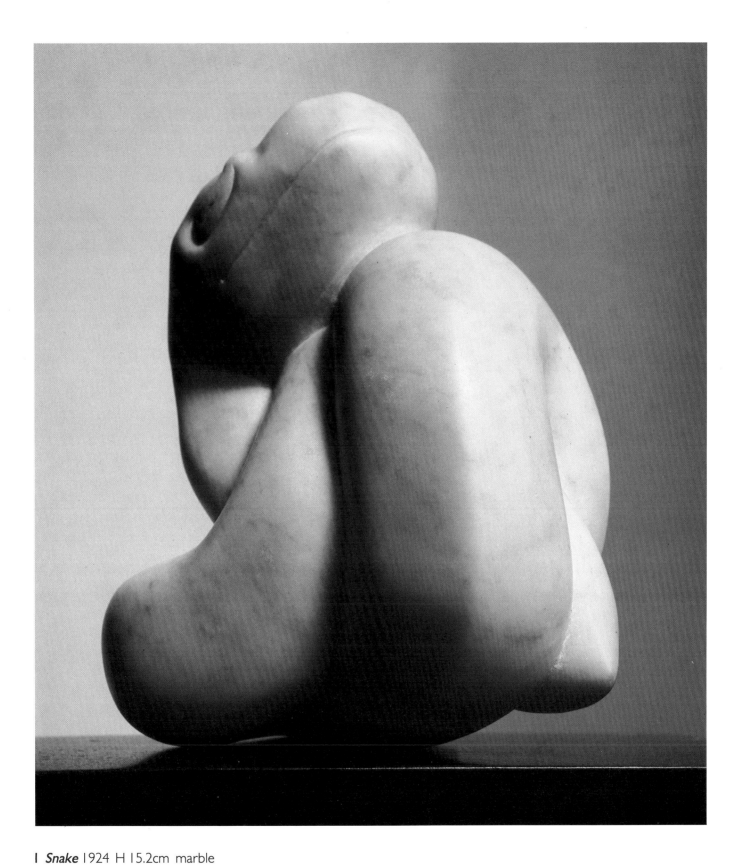

1 *Snake* 1924 H 15.2cm marble

A synthesis of form: idea and material combine to produce the snake's
tense compactness.

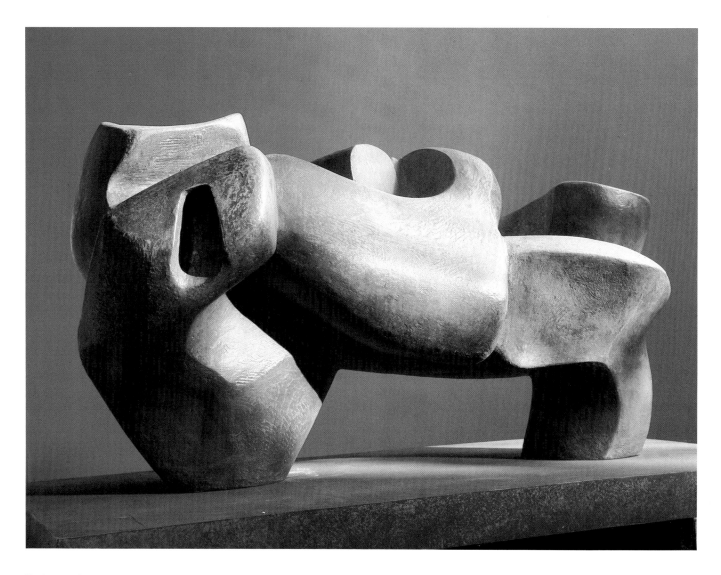

11 *Large Slow Form* 1962–8 L 77cm bronze, edition of 9

'It is a matter of wonder', wrote Gilbert White of the tortoise, 'that Providence should bestow such a profusion of days and such seeming waste of longevity on a reptile that appears to relish it so little.'

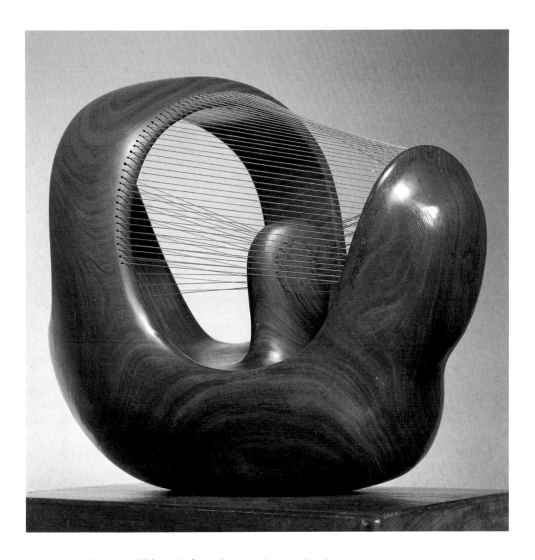

III, IV *Bird Basket* 1939 L 41.9cm lignum vitae and string

'It wasn't the scientific study of the mathematical models that excited me but the ability to look through the strings as with a bird cage and see one form within another.'

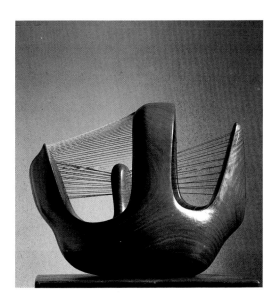

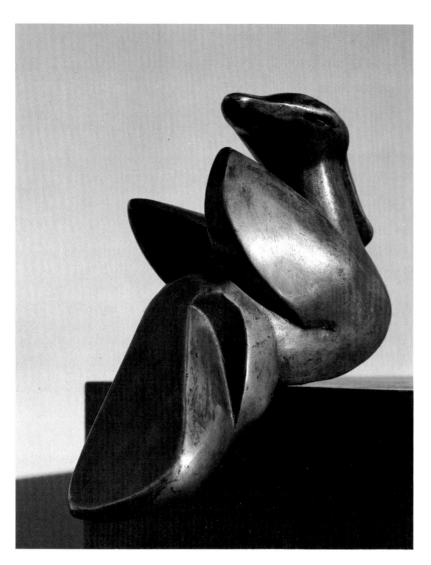

V *Bird* 1927 L 22.9cm bronze

The equilibrium effected between the base and the figure underlines the impression of a perching bird.

VI *Bird* 1955 L 14cm bronze, edition of 12

'One of the things I would like to think my sculpture has is a force, a strength, a life, a vitality from inside . . .' Here the voracity of the young bird is strikingly evident.

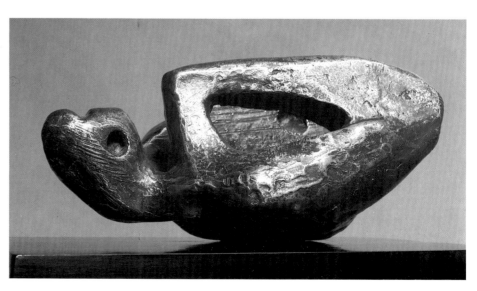

country, but for his first carving of this subject Moore found his inspiration in an Aztec stone rattlesnake seen in the British Museum, about which he has since commented: 'Although the snake is coiled into a most solid form, it has real menace, as if it could strike at any moment.' Moore's marble *Snake* carving of 1924 (1) is similarly compact but more objectively rendered, with concentration on the form. He had contemplated the subject three years before, as we see on a page of drawings in a Sketchbook of 1921/22 (2), one of which, marked with a cross, shows the same viewpoint as that chosen for illustrating the sculpture.

The *Head of Serpent* (3) is an extension of the 1924 *Snake*, picking up the main feature of the latter, the head and mouth. Angled like a gargoyle and as menacing as many of them are, it is carved in warmer travertine marble, the attractive graining of which shows to advantage in the long blunt head, emphasized by the narrow eyes which lead our gaze to the gaping mouth. Meaning through shape.

The *Snake Head* of 1961 (5) is raised in attack, rearing up like the head in a Sketchbook of 1935 (125) the eyes as impersonal as those of the interior of *Helmet Head No. 2* (30). Also in bronze, the *Serpent* of 1973 (6) conveys the sense of power through the single strong curve and the thickness of the tail. Again our eyes are irresistibly drawn to the head, equally telling seen from the side or above. It captures the very essence of snake.

Moore's only other reptilian work is *Slow Form: Tortoise* (8). The second part of Moore's titles usually indicates the initial pretext of the piece, as in *Standing Figure: Knife Edge* or *Reclining Figure: Bone*. Here, however, it is the reverse process; the tortoise is identified with that creature's dominant characteristic, slowness. One can say of this piece 'in the beginning was the form', since basically it is an integration of interlocking square forms. Indeed, there is more resemblance to the creature tortoise in the travertine marble carving entitled *Animal Form* of 1969 (Plate XV). To the bronze *Slow Form: Tortoise* on the other hand Moore gives the same armour-plated feeling to the creature's carapace as he suggests for the hide of the rhinoceros in his sectional line drawing (153).

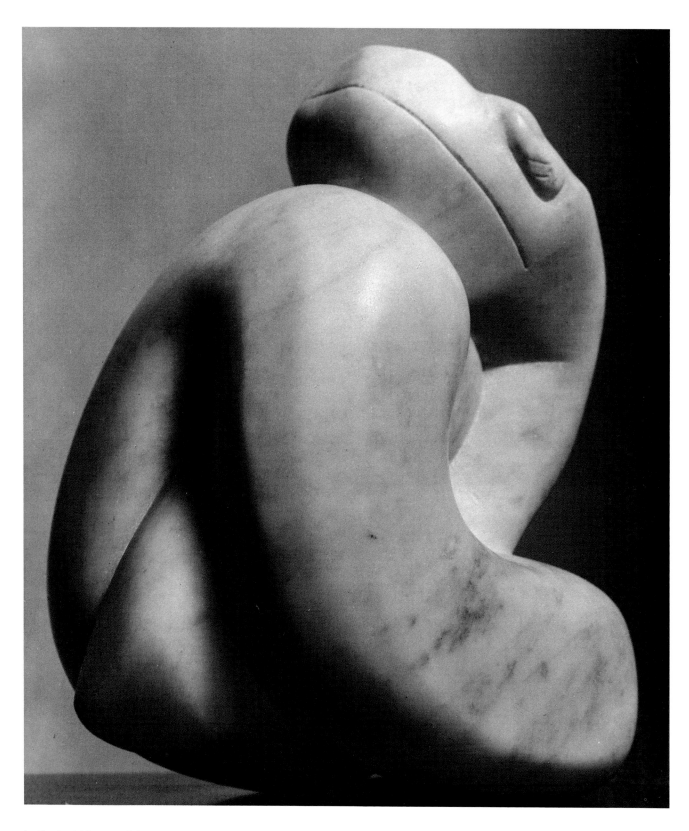

1 *Snake* 1924 H 15.2cm marble

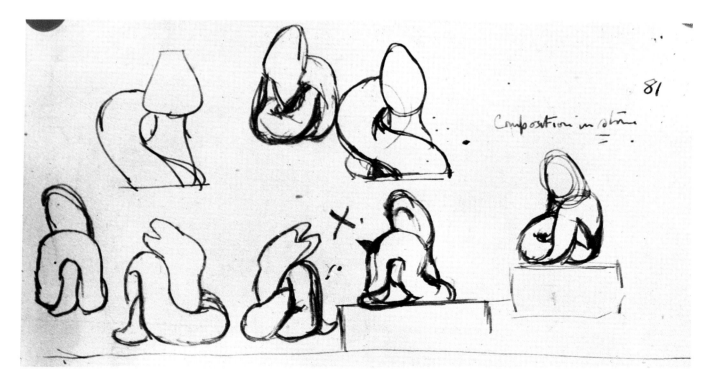

2 *Drawing for Marble Snake 1924:* detail of page 81 from No 2
Notebook 1921/22 22.5 × 17.2cm pen and ink

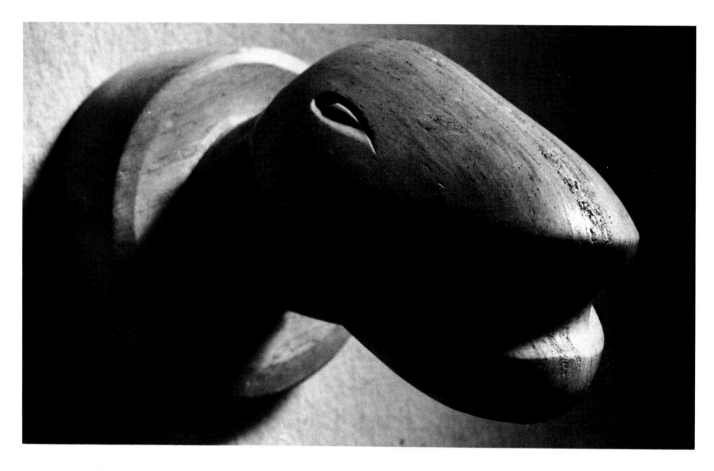

3, 4, *Head of Serpent* 1927 H 20.3cm stone

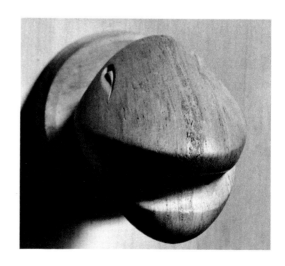

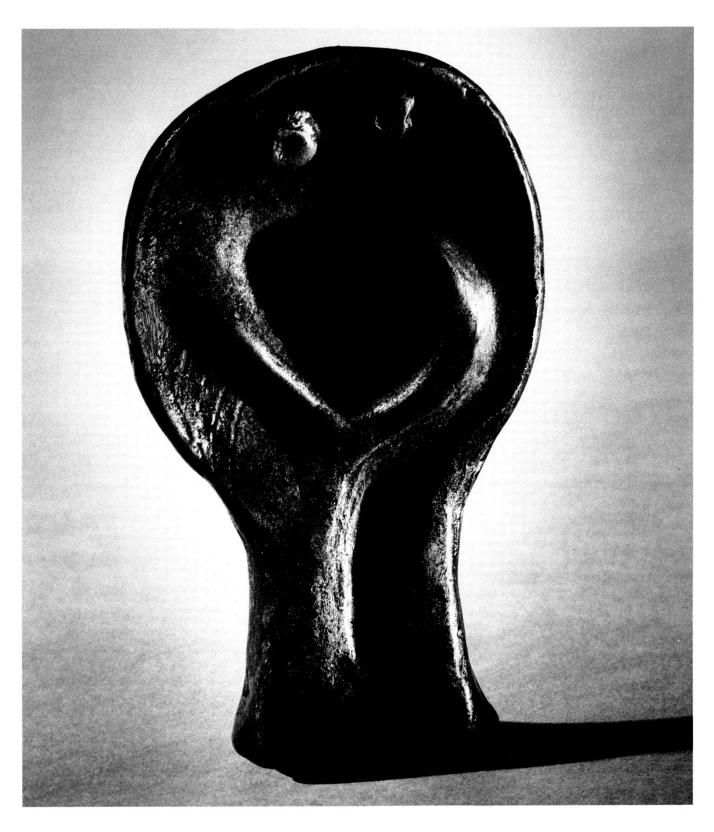

5 *Snake Head* 1961 H 10.2cm bronze, edition of 6

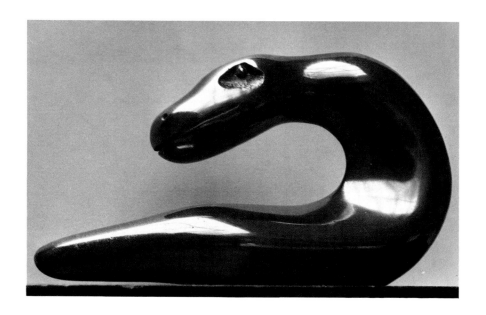

6, 7 *Serpent* 1973 L 24cm bronze, edition of 9

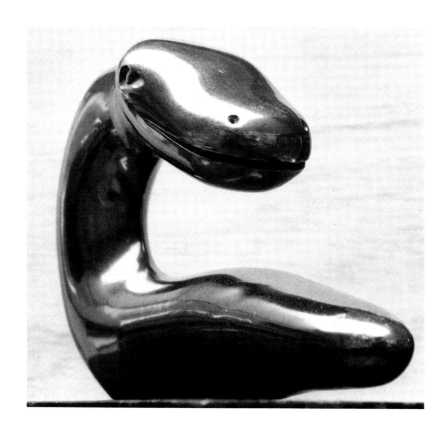

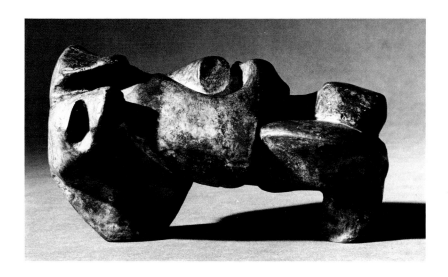

8 *Slow Form: Tortoise* 1962 L 21.6cm bronze, edition of 9

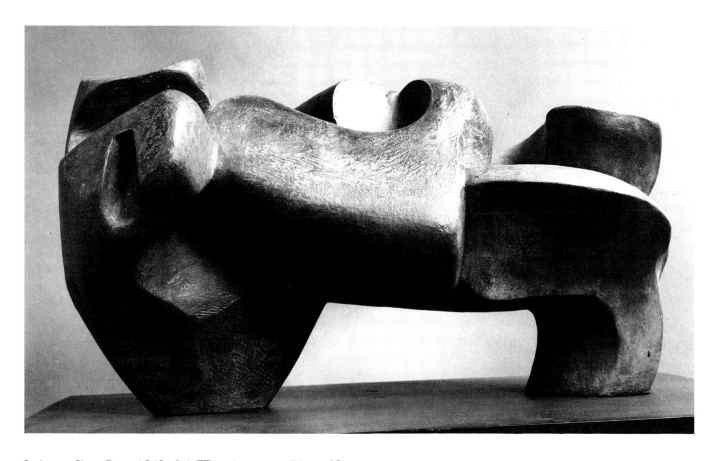

9 *Large Slow Form* 1962–8 L 77cm bronze, edition of 9

2 BIRDS AND INSECT FORMS

*The very small or very large take on an added
size of emotion* – Henry Moore

The attractive *Bird Table* (10) that Henry Moore modelled in clay for
his wife and daughter in 1954, and that no visitor to his house
Hoglands can fail to notice, symbolizes the interest the Moore family
takes in birds. Moore is fascinated by both bird structure and bird
behaviour. In the matter of representational drawing on this theme,
no living draughtsman can compare with him when he chooses that
mode of expression. We see in his drawing *Three Crows* (22) how he
has not only set down the salient features but captured the stance and
comic character of a bird for which he admits a special affection.
Similarly in the portrayal of the *Vultures* (145) he sums up the whole
predatory nature of the bird in the expression of the hooded eyes and
the curved beak.

The fact that we recognize birds by shape rather than colour – as
every admirer of Bewick's wood engravings would agree – enables us,
when it comes to sculpture, to appreciate the liberties Moore takes
with bird forms in the interest of the final carving or bronze. A glance
at some of his sketchbook studies of bird artefacts from primitive

civilizations reminds us of his statement, 'nine-tenths of my knowledge and understanding of sculpture has come from the British Museum'. Three pencil sketches (11, 13, 14) are copies, if indirectly, from such sources, two being from a reproduction of an Inca pot, the third from a negro tribal source. They prepare us for the non-descriptive nature of the bird sculptures, as do the small drawings Moore labels 'grotesques' in the same sketchbook.

Spanning more than four decades, Moore's bird sculptures nevertheless show a consistent development in formal language, from the near-geometrical shapes that compose the bronze *Bird* of 1927 (15) to the final reductive black marble carving *Bird Form I* of 1973 (28), summed up in the enlarged eye and uptilted beak. The *Duck* 1927 (17) is a more solid form – to some extent conditioned by concrete casting – than the bronze *Bird*, which is characterized by the fine balance of the component parts – wings, beak and tail. The *Duck* offers an interesting comparison with Brancusi's carving *Leda*, which in turn is curiously reminiscent of a sketch of Moore's (18). Neither sculptor is concerned here with appearances but with synthesis of form: it is as if these shapes were in the air at the time.

By 1934, when Moore carved *Bird and Egg* (19) in alabaster – a material he likes for its 'close-knitted construction' – the 'egg' owes less, if indeed anything, to Brancusi's obsession with the ovoid form than to the sculptor's subconscious mind. The relation between the bird and the egg – apart from that of their precisely judged distancing, a feature of all Moore's multipiece works – has been variously explained. I am satisfied to think of the hollow on the bird as offering a haven for the egg. This piece can certainly be claimed as a contribution to surrealist sculpture.

Bird Basket of 1939 (12) is perhaps the most successful outcome of Moore's experiments with stringed figures. Intrigued by the mathematical stringed figures he saw in the Science Museum, which made visible normally invisible intersections of planes, he was eager to exploit their sculptural potential. The whole asymmetrical carving, in tough lignum vitae with its attractive grain, is much more compact than many of his other stringed figures. The strings passing through the bird's head to the 'tail' end and from the latter to the basket handle compose a tightly knit form.

The fledgling theme first attracted Moore in 1955 when, having made the bronze *Object: Bird Form* (20), itself based on a holed flint, he developed this into *Bird* (21). Everything here is concentrated in

two features: the expectant, raised head and the hollowed-out wing shapes. This was followed in 1960 by *Fledgling* (25), which emphasizes the straggliness of the immature bird. The *Fledglings* of 1971 (26), two separate but complementary polished bronzes, anticipate the forms of the two *Bird Form* carvings of 1973. They represent a return to synthetic statements, and the up-turned beak of the fledgling on the right illustrates Moore's observation that an outward-faced point suggests movement with – in this case – the left-hand figure also acting as a 'stop'. The black marble carvings *Bird Form I* (28) and *Bird Form II* (27) bring the fledgling theme to a triumphal conclusion, a superb summing-up in an eye and a beak.

In between these fledglings Moore produced the strangest and the most imaginative of his birds – paradoxically, from a more than usual basis of reality. 'A big black crow used to come and eat from the bird table. It had something wrong with its beak and stood almost horizontally. That is why I did this sculpture.' The sweeping form of *Bird* 1959 (23) is equally effective seen from every angle, and the sculptor agreed that the artefact *Wooden Rattle* (p. 45), a piece of native art from British Columbia, carved in the form of a raven and coincidentally almost the same size as Moore's crow, made an interesting parallel. If this is the most fantastic of Moore's bird sculpture, *Owl* (29) is the most figurative. It was originally done as a demonstration of modelling to his daughter Mary when a child, but was not cast until 1966.

Except for incidental insect analogies described in the captions, which explain their inclusion in this section, Moore's excursions into the insect world have been limited to his Butterfly (surrogate Lepidoptera) series. Early in the evolutionary sequence, and therefore it would seem arbitrarily placed after the Birds, their annexation into Moore's work at a comparatively late date justifies this order. They belong to his second carving period, identified with the summer months spent with his family at Forte dei Marmi from 1965 onwards. *Divided Oval: Butterfly* (33), a carving in white marble, was executed in 1967. The next carved *Butterfly* (35), also in marble, followed after a ten-year interval but was based on a bronze *Butterfly Form* of 1976 (34), as can clearly be seen from one particular angle of the carving.

These Butterfly pieces, particularly the carvings, have an important place in Moore's work, not only as imaginative interpretations of Lepidopteral form but for the exciting multiplicity of view-points they offer.

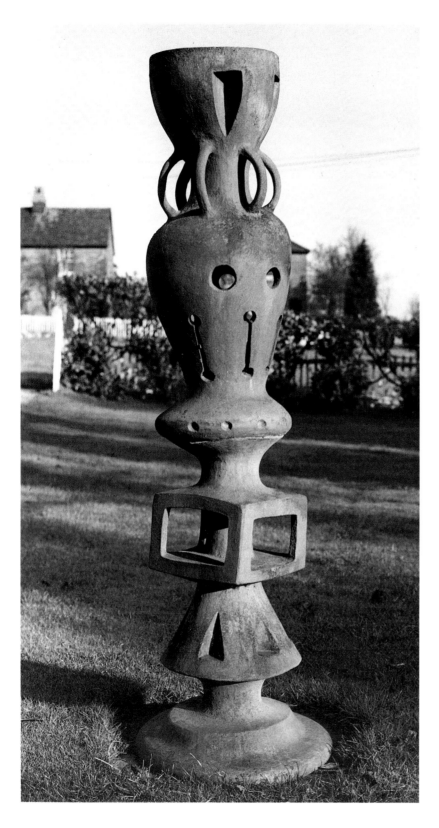

10 *Bird Table* 1954 H 1.5m terracotta

11 *Sketch based on negro artefact:* detail of page 102
from No 3 Notebook 1922/24 22.5 × 17.2cm pencil

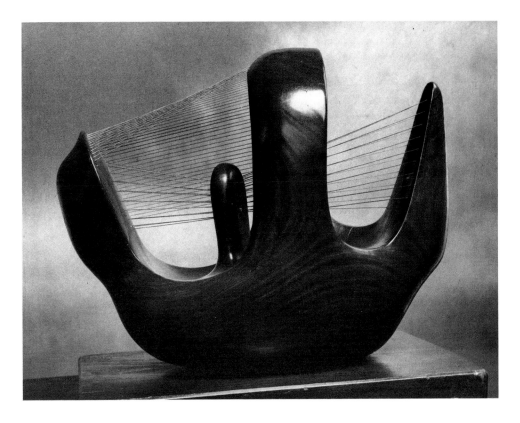

12 *Bird Basket* 1939 L 41.9cm lignum vitae and string

13 *Copy of upper portion of an Inca pot from Chimbote:* detail of page
101 from No 3 Notebook 1922/24 22.5 × 17.2cm pencil and chalk

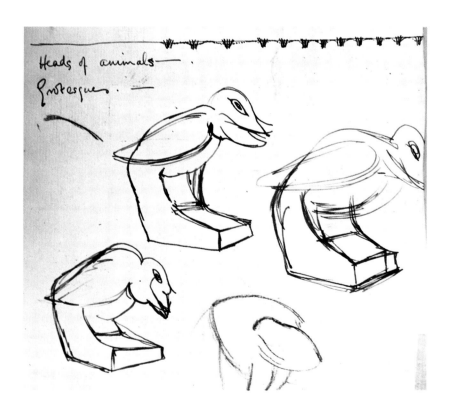

14 *Heads of Animals:* detail of page 82 from No 2 Notebook 1921/22
22.5 × 17.2cm pen and ink, chalk

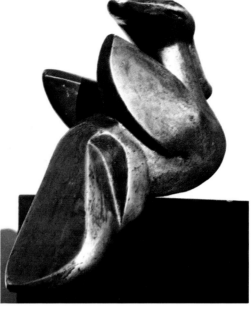

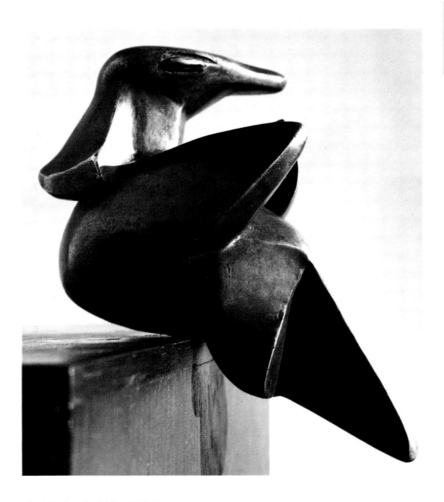

15, 16 *Bird* 1927 H 22.8cm approx bronze cast

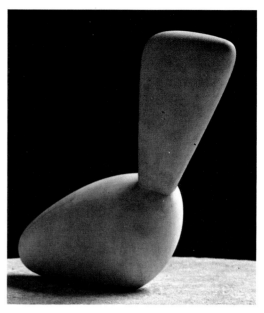

Leda Brancusi, 1920, marble

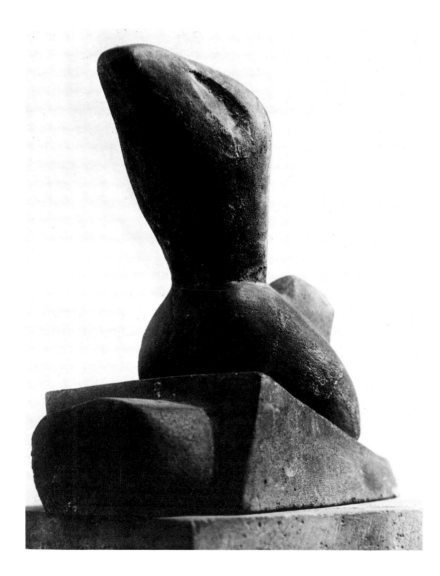

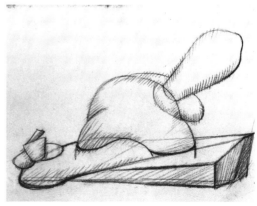

17 *Duck* 1927 H 15.2cm concrete

18 *Idea for Sculpture:* detail of page 34 from No 2 Notebook 1921/22 22.5 × 17.2cm pencil

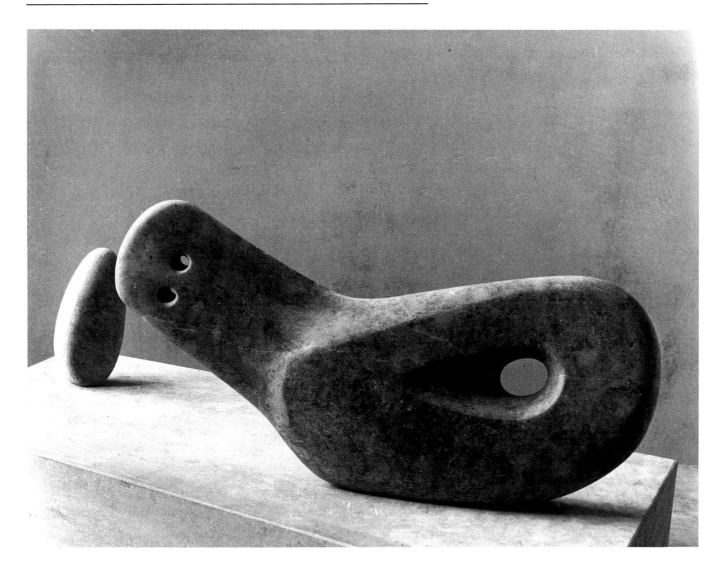

19 *Bird and Egg* 1934 L 55.9cm Cumberland alabaster

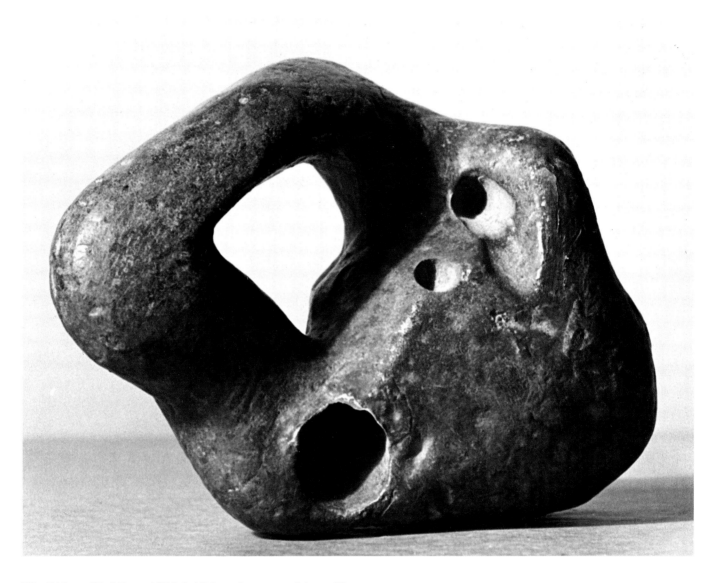

20 *Object: Bird Form* 1955 L 10.2cm bronze, edition of 9

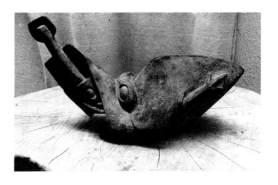

Bird swallowing a fish Henri Gaudier-
Brzeska (undated), carved plaster

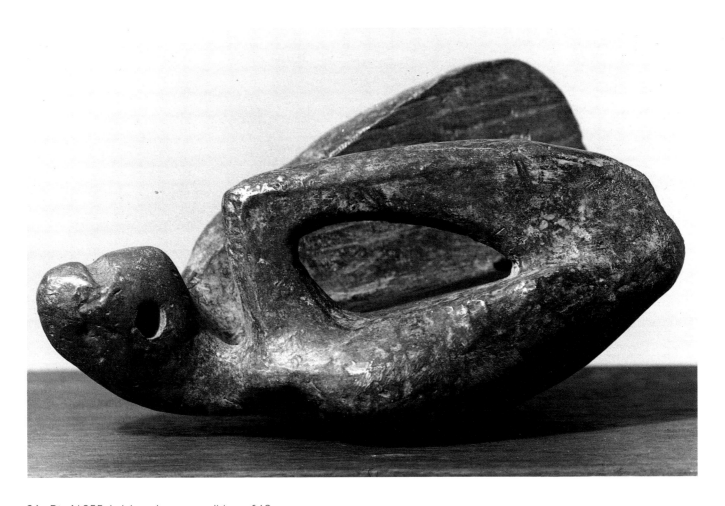

21 *Bird* 1955 L 14cm bronze, edition of 12

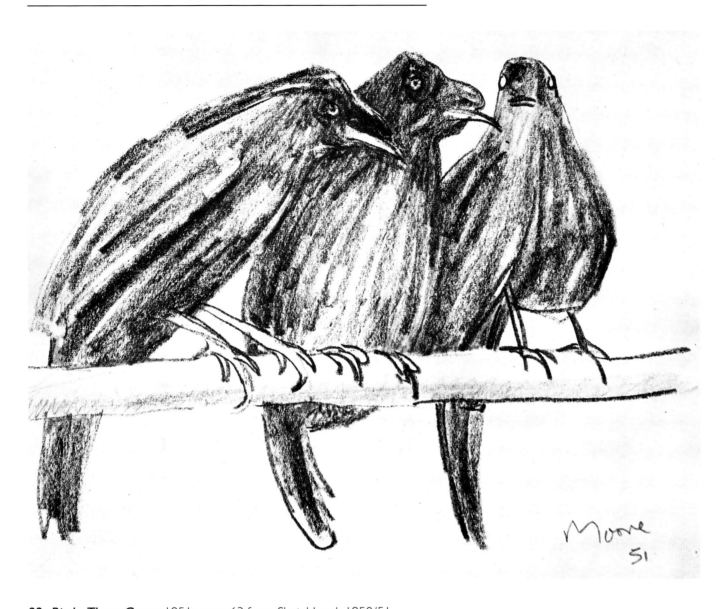

22 *Birds: Three Crows* 1951: page 63 from Sketchbook 1950/51
18.8 × 21.6cm pencil

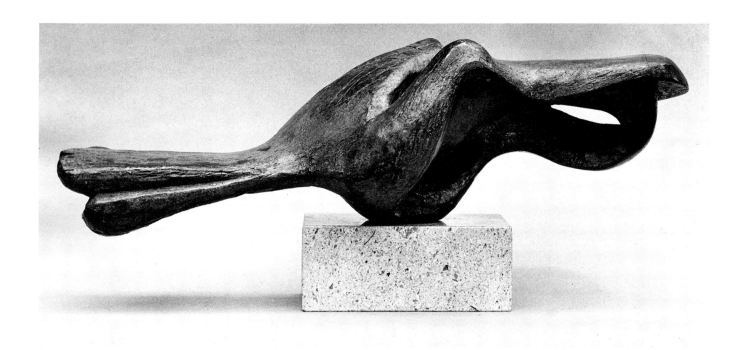

23 *Bird* 1959 L 38.1cm bronze, edition of 12

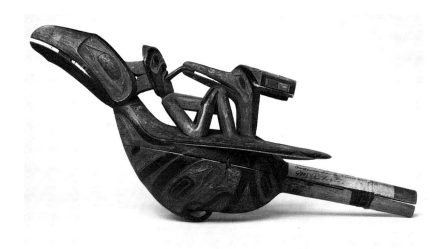

Wooden Rattle British Columbia, 19th century

24 *Bird feeding young bird:* detail of page 84
from No 2 Notebook 1921/22
22.5 × 17.2cm pen and ink

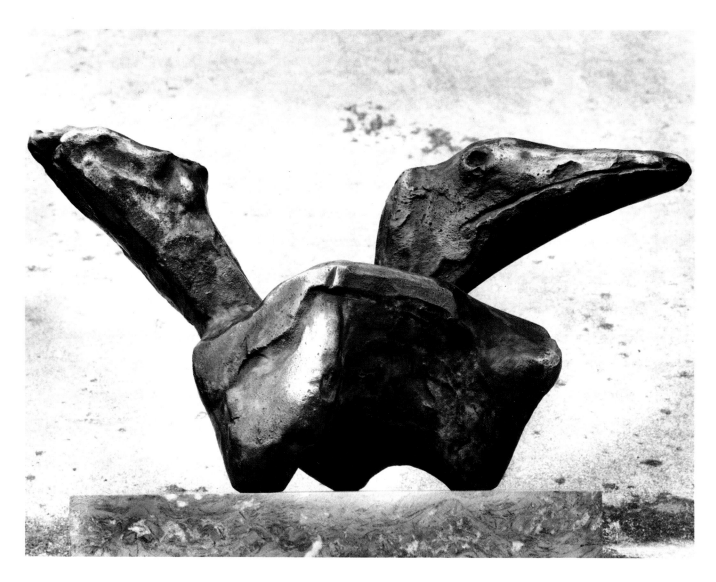

25 *Fledgling* 1960 L 17.8cm bronze, edition of 9

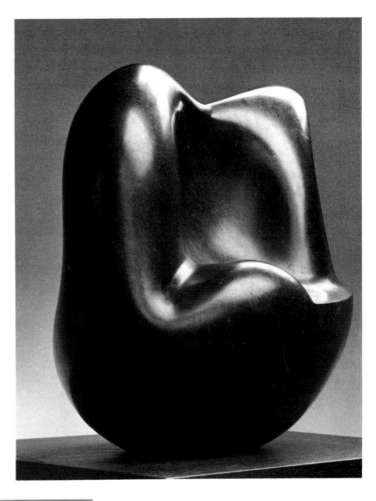

27 *Bird Form II* 1973 L 40cm black marble

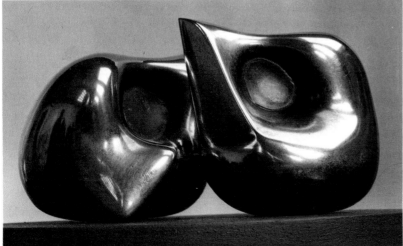

26 *Fledglings* 1971 L 16cm bronze, edition of 12

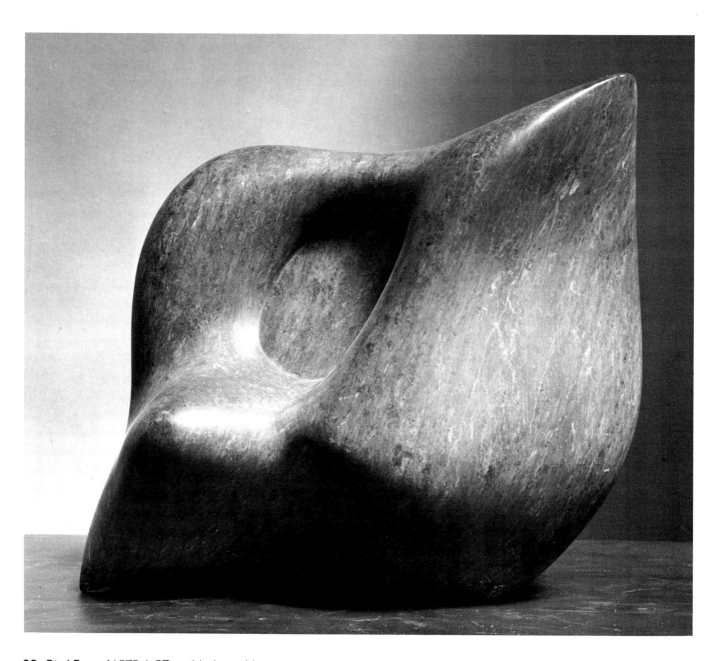

28 *Bird Form I* 1973 L 37cm black marble

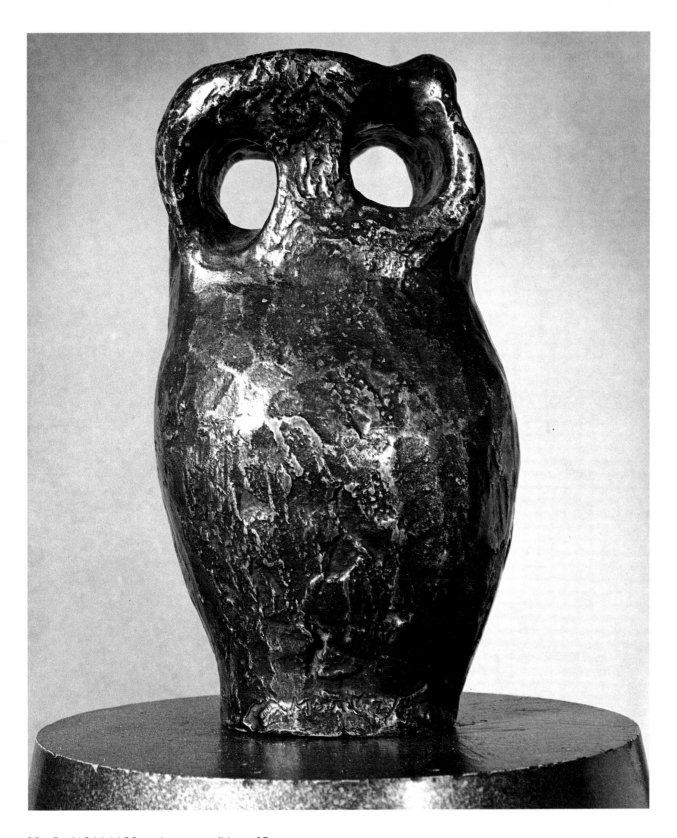

29 *Owl* 1966 H 20cm bronze, edition of 5

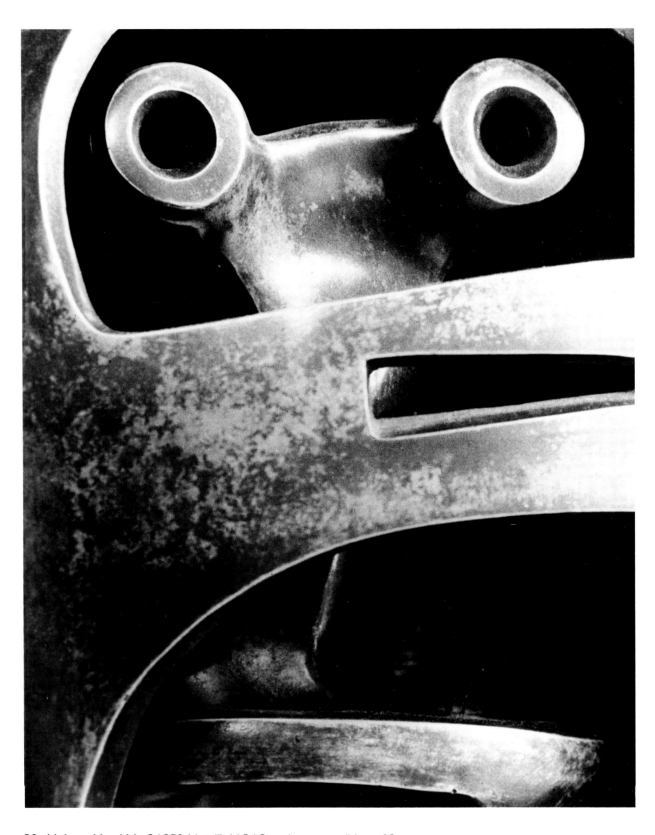

30 *Helmet Head No 2* 1950 (detail) H 34.3cm bronze, edition of 9

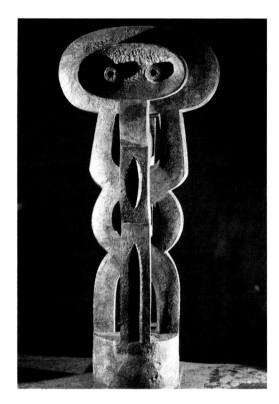

Figure Jacques Lipchitz, 1930
This bronze offers a striking parallel to
Moore's treatment of the movable part of
Helmet Head No. 2 (30).

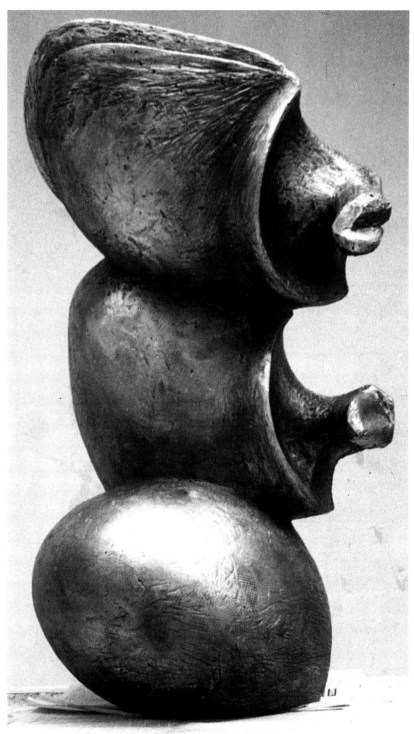

31 ***Three Part Object*** 1960 H 1.2m bronze, edition of 9

51

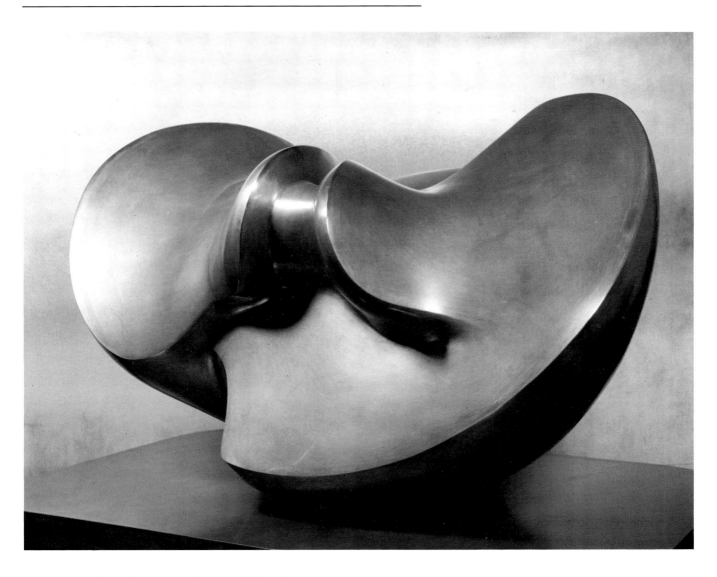

32 *Divided Oval: Butterfly* 1967, cast 1982 L 91 cm bronze

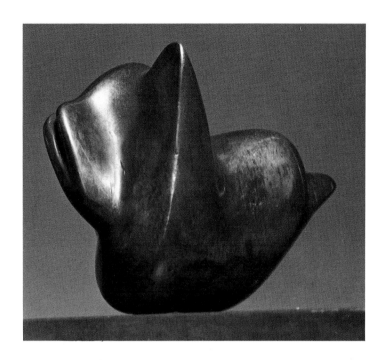

34 *Butterfly Form* 1976 L 16.5cm bronze, edition of 7

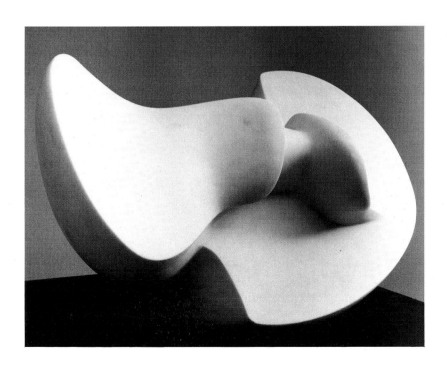

33 *Divided Oval: Butterfly* 1967 L 91cm white marble

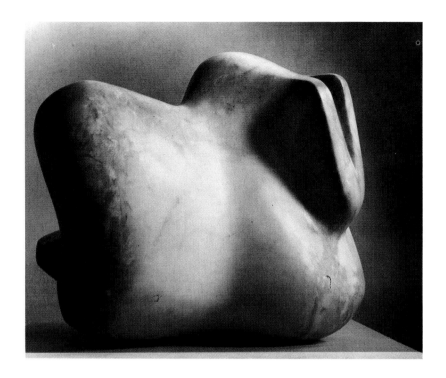

35, 36, 37 *Butterfly* 1977 L 47cm marble

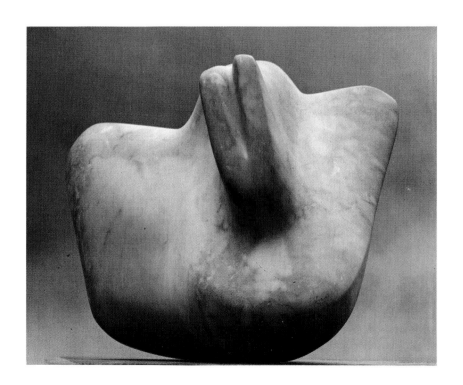

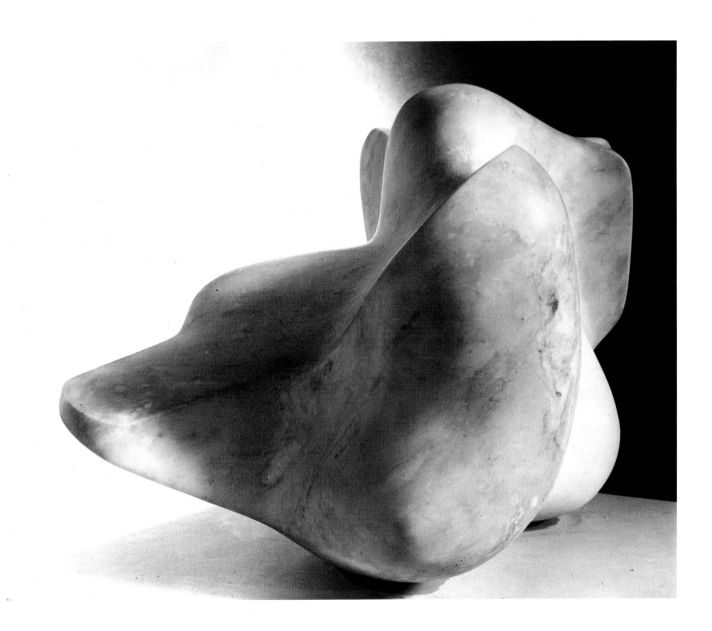

3 DOMESTIC ANIMALS

It is not the outward form which is real, it is the essence of things. It is impossible for anyone to express anything by imitating surface appearances – Constantin Brancusi

THE HORSE

A remark made by Moore early in his career gives a clue to his interest in the horse and one aspect of his attitude towards it: 'I have always liked the shape of horses though I haven't used them much in my sculpture.' In 1950 he was to remedy this omission. He produced three different horses in bronze, and followed these in 1960 with the piece *Animal: Horse* (43). They differ totally in conception from the first horse he did, in 1923 (42), which itself marks a rejection of the traditional classical horse, though a drawing probably after Piero di Cosimo occurs in a notebook of 1922/24 (46). In a sketchbook of the previous year Moore devoted a whole page to a series of explorations, 'animal ideas for sculpture'. Half-way down the page he wrote, 'abstract further' – a significant comment applicable to much of Moore's work. In this case the final synthesis, marked with a cross, never reached a three-dimensional stage, probably because he had set his mind against representing physical movement in sculpture. (The only exception to this is his relief carving *West Wind* 1928–9, a commissioned work at St James's Underground station, London.)

Another drawing (40), undated and more elaborate, copied from a Scythian bronze, adopts a similarly synthetic approach. The stylization is not that of the Renaissance and it prepares us for Moore's own original treatment of the horse in the bronzes.

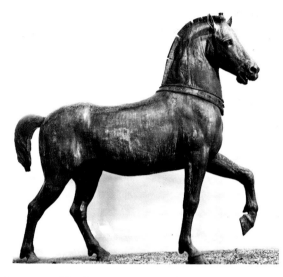

Horse San Marco, 4th–7th century, bronze One of the four famous Greek bronze horses brought from Constantinople in 1204 and sited over the central doorway of the Basilica San Marco, Venice.

Yet as late as 1981 Moore returned to the Renaissance model, pressing into service horses heads he had gazed at with admiration during his time in Florence in 1923 (p. 70). They are the horses on the bronze relief gates, *la Porta del Paradiso*, of the Baptistery, the work of Ghiberti. Moore picked out this detail in a photograph of the panel depicting the battle between David and Goliath. We discussed his drawing. I remarked on the emphasis given to the bony structure of the heads. 'Yes, that,' he said, 'and the pathos in their eyes.' I thought the separate drawing of bones might have been suggested by an imagined aerial view but, no, they were just 'invented bone forms'; but he agreed about the relation in feeling to the heads. I wondered about the omission of the fifth horse in his transcription. 'I came to the end of the paper!' was his reply.

To return to the bronzes, the first *Horse* (42), made in 1923, is the only one that developed from a drawing and to which the sculpture adheres quite closely. It is a mere 10 centimetres high but, like all Moore's bronze horses, each on a small scale, it has none of the accent on musculature, sinew and realistic detail that characterizes Renaissance small bronze statuettes, of which Riccio's *Mounted Warrior* in the Victoria and Albert Museum is typical. Nor does this horse of Moore's, or any of his subsequent bronzes, bear any resemblance to the

horses of his contemporary Marino Marini who also had an alternative to the classical image. Moore introduces his own expressive distortions which always emphasize some characteristic of the animal, its nature or behaviour, but with shape as the essential pretext. The first bronze, with its fleshy curves and static serenity, is an affectionate evocation of the 'little horse' in a sculpturally – if not anatomically – satisfactory pose. The *Horse* of 1959 (45), with its pricked-up ears and general air of alertness, has a similar stance to the previous bronze; a rhythmic energy runs through the figure from its nose to the tip of the exaggerated tail. In the next two bronzes, the descriptive element is left far behind. *Rearing Horse* (44) is an imaginative rendering of the nervous nature of an animal liable to find an outlet in panic. The ridge across the chest is anatomically inexplicable, but, as with a comparable idiosyncratic ridge on the rib-cage of Rodin's *L'Homme qui marche* (of which Moore has a cast) it seems necessary. Both illustrate an observation made three hundred years ago by Sir Francis Bacon: 'There is no exquisite beauty without some strangeness in proportion, some blemish.'

Many viewers will perhaps find *Animal: Horse* (43) easier to accept, since it is so evidently a creation of the imagination. Seldom has such power, such originality of form been concentrated into so small a bronze. It belongs, like the *Horse's Head* (Plate XVIII), the animal heads and animal forms, to other fields than those of safely grazing sheep, and reminds us that the artist lives at least part of the time in an irrational world to which our only access is through his work, and that he can give corporeal shape to whatever his unconscious mind may suggest. This is the magic of art. Moore has often expressed a preference for those artists in whose work there is 'a disturbing element, a distortion, giving evidence of a struggle of some sort.' We should not therefore be surprised if this factor is present in some, if not all of his own creations.

Moore's boxwood carving of 1921, *Small Animal Head* (113) is more equine in form than *Horse's Head* of 1980 (Plate XVIII), although both seemed more at home among the Animal Heads. It does, however, provide an interesting comparison with the Donatello *Gattemalata* head, with the Braque romantic *Horse's Head* relief and with Moore's own Circus horse (38). The arched head of the *Circus Rider*'s horse belongs to the prancing animals beloved of Seurat and Toulouse-Lautrec, but there are no poetic overtones in Moore's realistic treatment of the female rider. The whole drawing has been

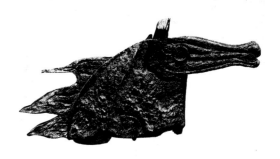

Horse's Head Georges Braque, 1943, bronze relief

woven as a tapestry – a most successful interpretation, transforming the charcoal lines and gouache of the original work, done on 'water-coloured' blotting paper, into a weft of line and beautifully gradated soft tones. Moore's *Horse and Rider* drawing (48) in mixed media shows a free rendering of a 'classical' horse – like the Circus horse with one front leg raised – characterized by vibrant, nervous lines (not unlike those used by Giacometti in his drawing of the same subject) that give it great animation and spontaneity.

Moore's drawings of pit ponies, executed in a Coalmine Sketchbook of 1942, are in starkly contrasting mood. They were drawn in a mine at Wheldale Colliery in Castleford, from life and under difficult conditions. Apart from the usual question of capturing continual movement, they posed the problem of drawing from black to white instead of the normal process of making black lines on a white surface. The human figures emerge dimly from the darkness, lit only by the lamp on the boy's helmet. The whole concentration is on catching such accents of light – on the pony's nose, the steel tracks, the boy's head. Working in these conditions gave Moore a further respect for the graphic methods of Seurat, already one of his favourite artists.

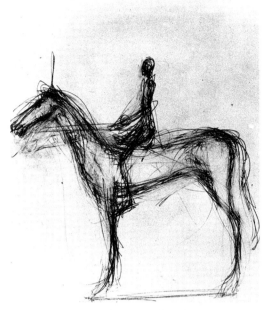

Horse and Rider Augusto Giacometti, 1950, pencil

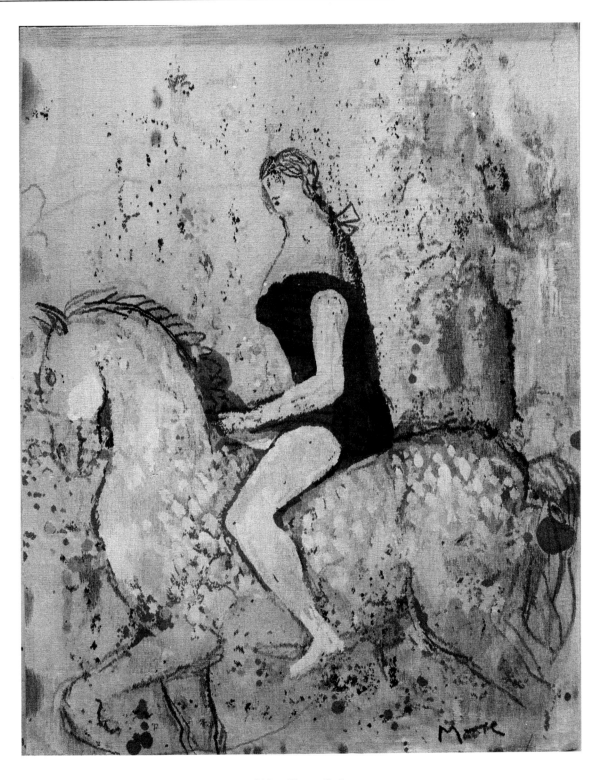

38 *Circus Rider* 1979: tapestry woven at West Dean College
(The Edward James Foundation) from a drawing of 1975 2 × 1.7m

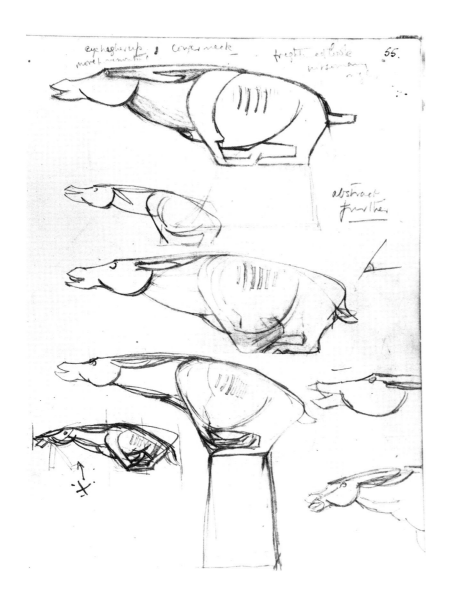

39 *Ideas for Animal Sculpture:* page 55 from
No 2 Notebook 1921/22 22.5 × 17.2cm
pencil

40 *Study after Scythian Horse* (undated) 21 × 29.8cm charcoal

41 *Idea for Sculpture: Horse* c. 1922 9.5 × 15.2cm pen and ink

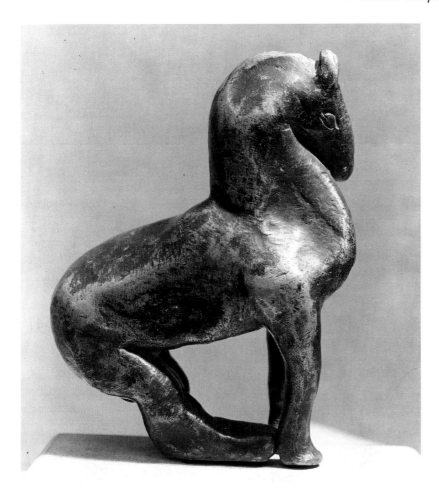

42 *Horse* 1923 H 10.2cm bronze, edition of 3

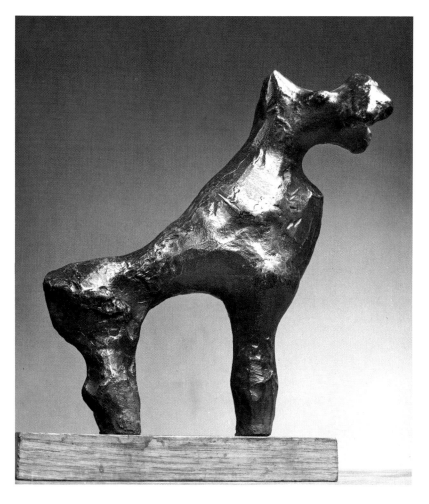

43 *Animal: Horse* 1960, cast 1965 H 17.8cm bronze, edition of 6

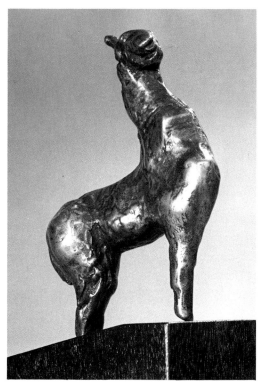

44 *Rearing Horse* 1959, cast 1972 H 20cm
bronze, edition of 9

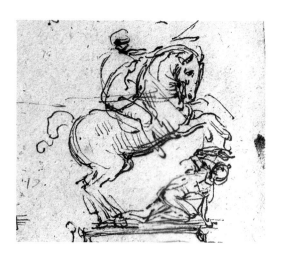

Studies for Trivulzio monument (detail)
Leonardo da Vinci, pen and ink

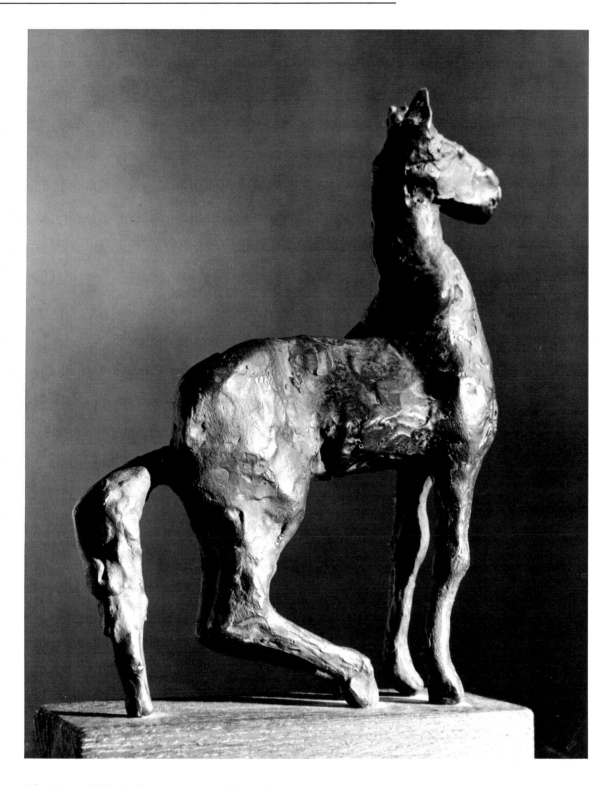

45 *Horse* 1959 H 19cm bronze, edition of 2

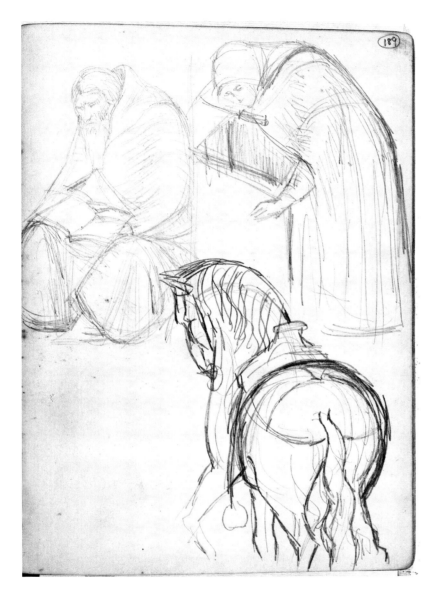

46 *Studies after a Trecento Italian painting:* page 189 from No 3
Notebook 1922/24 22.5 × 17.2cm pencil

47 *Circus Rider* 1979: detail of tapestry (38)

48 *Horse and Rider* 1982 17.6 × 19.4cm ballpoint pen, crayon, watercolour wash, gouache

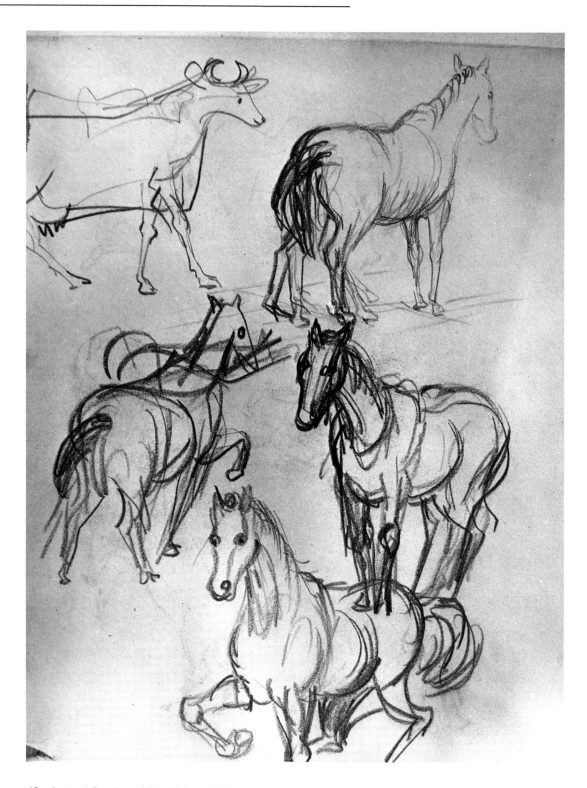

49 *Animal Studies* 1950 29.2 × 23.8cm pencil

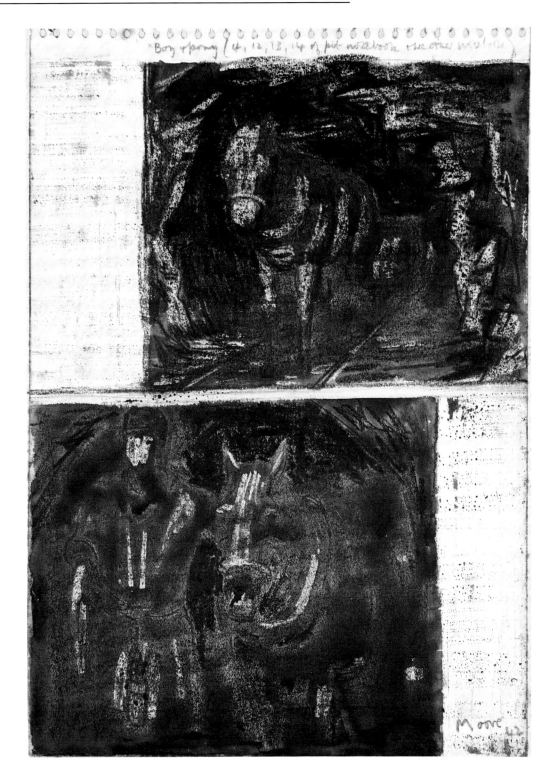

50 *Boy and Pony:* page from Coalmine Sketchbook 1942
25.1 × 17.8cm chalk, crayon, watercolour wash

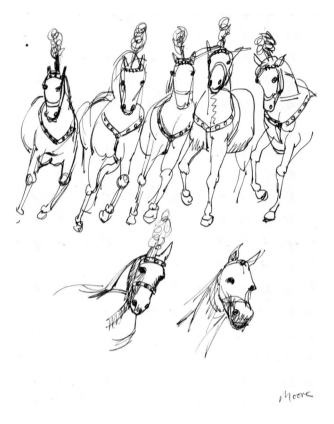

51 *Horses at the Circus:* page from Sketchbook 1955/56
29.2 × 24.2cm pen and ink

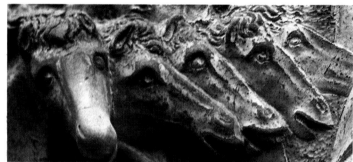

La Porta del Paradiso (detail) Lorenzo Ghiberti, *c.* 1420–25,
bronze Baptistery gates, Florence

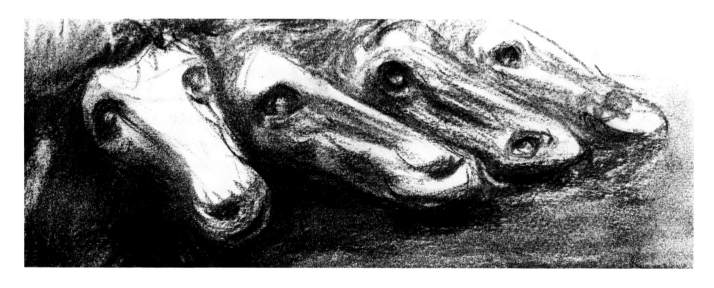

52 *Horses' Heads* 1981: Study after Lorenzo Ghiberti, David – panel 9
from 2nd baptistery doors (*Porta del Paradiso*) 10.8 × 25.4cm soft
pencil, charcoal

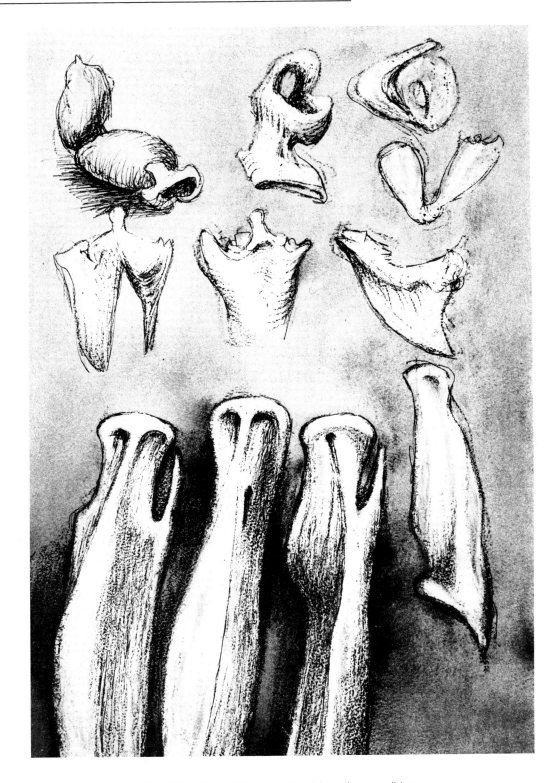

53 *Three Sisters* 1981 35.3 × 25.1 lithograph in eight colours, edition of 50 + 15

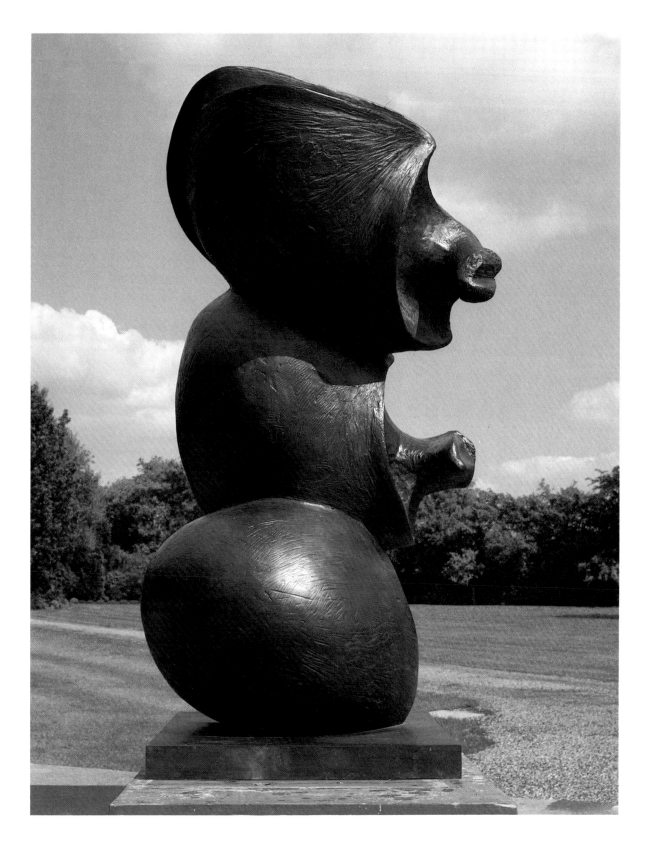

VII *Three Part Object* 1960 H 1.23m bronze, edition of 9

An unusual three-part vertical composition in surrealist mood,
different from every angle. Moore, who has likened it to a centipede,
commented: 'Sometimes a likeness is accidental . . .'

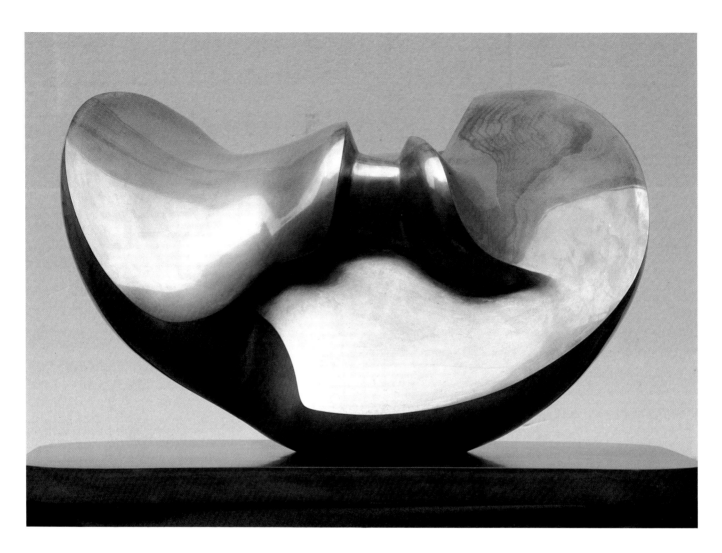

VIII **Divided Oval: Butterfly** 1967,
cast 1982 L 91 cm bronze

Compare this bronze, which stresses
the structure, with the marble carving
(33) where one is conscious of the
butterfly lightness.

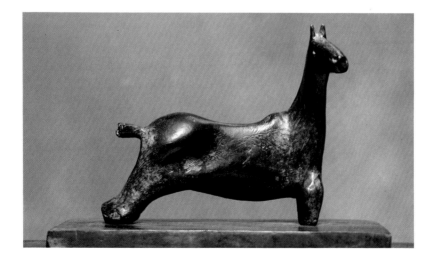

IX **Horse** 1978 L 21 cm bronze, edition of 7

Here the emphasis is on the long neck,
small alert head and muscular tautness,
expressed particularly in the
hindquarters.

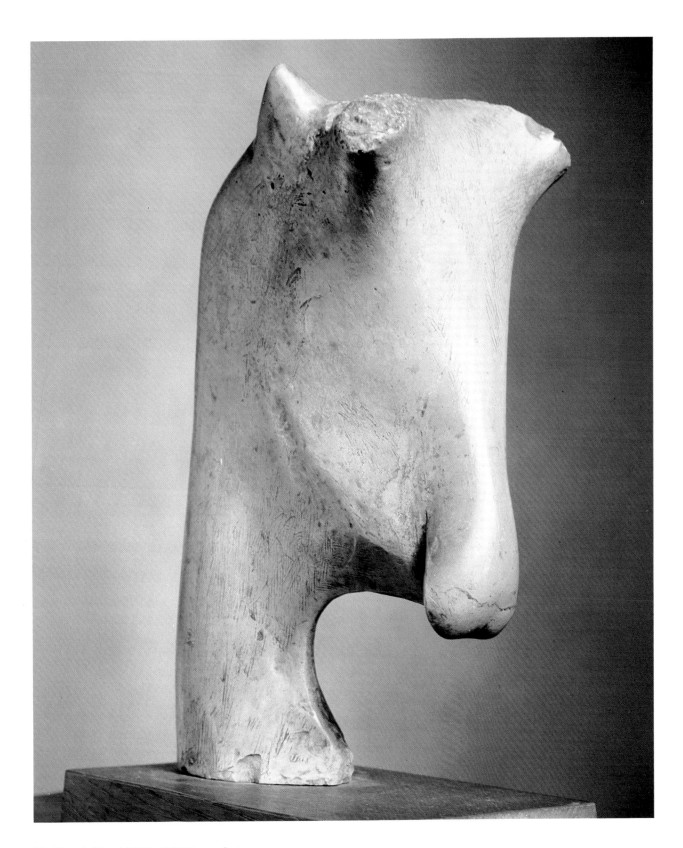

X *Goat's Head* 1952 H 20.3cm plaster.

This sculpture, a favourite of Moore's, sums up more than any other
his feeling for the bone beneath the skin.

XI, XII *Sheep Piece* 1971–2 H 5.7cm bronze,
edition of 3

'Sheep are just the right size for the kind of
landscape setting that I like for my sculptures . . .
the sheep posed as well as a life model in
art school.'

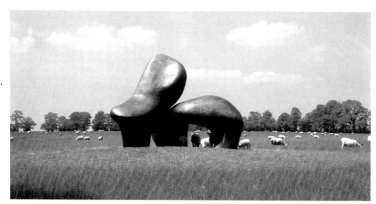

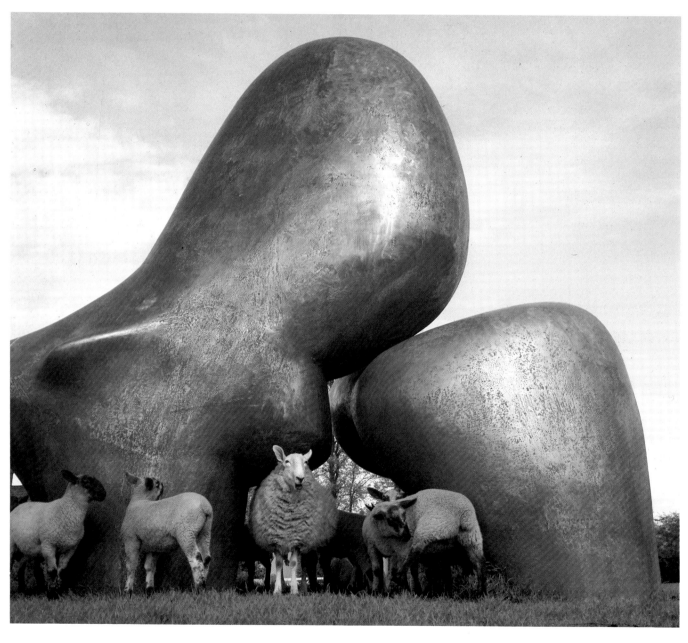

GOATS AND SHEEP

Since the *Goat's Head* sculpture of 1952 (54) precedes the famous *Sheep Piece* bronze by twenty years, it seems logical to reverse the order in which we usually think of these animals. The *Goat's Head* is especially important in that the piece was suggested by an actual bone – though not from that species – found in the grounds of the sculptor's house. Goats appear in a Moore sketchbook of 1921 (55, 56). Drawn from life, they catch the salient features, the horns, neat hoofs, strange slanted eyes and the movements of this active creature. By a coincidence the French sculptor Antoine Bourdelle (whose grand-father was a goatherd) was obsessed by goats in the way Moore was to be with sheep, and left many sheets of studies of them.

The goat has always been an irresistible subject to artists, and to sculptors in particular. Going back many centuries there is the *Forepart of a Goat* from the Caucasus, now in the British Museum, which perhaps unconsciously influenced Moore when he made a similar box version of a sheep in 1960 (68). Of other representations Moore likes the ivory netsuke in the form of a goat and kid illustrated

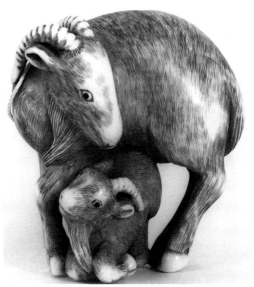

Netsuke Kyoto School, Japan, early 19th century, ivory

73

here, half the size but with all the tenderness of the *Head of a Ewe* shown in the introduction (p. 16). Two of Moore's contemporaries have portrayed characteristic versions of goats and sheep in their favoured media – Jean Lurçat in his surrealist tapestry and Graham Sutherland in his mixed media drawing.

No domestic animal is invested with more symbolism or evokes in our minds more visual and literary imagery than the sheep. A well-known example on a misericord in Winchester College chapel portrays a medieval shepherd with a lamb under each protective arm. A more descriptive fifteenth-century carving of a sheep on a bench-end in the Suffolk church of Tostock emphasizes its luxuriant fleece, appropriately in a county once so prosperous in the wool trade.

Moore had made studies of sheep from life in his early days during holidays in Norfolk. Seen beside examples of sheep drawn in similar attitudes in his Sheep Sketchbook of 1972 they show what new strength and maturity informs the latter. A comment of Moore's in this context is so generally applicable to an understanding of the duality in his work that it should be quoted in full. Surprise had been expressed that Moore should draw sheep '. . . as if it's unnatural to draw from nature, as though one should become what you may call a sculptor of forms that are invented, as though you shut your eyes to nature – it's a silly attitude, I see no difference, it's just two points of view – one you draw directly from nature, the other you use your sum total of information and repertoire from nature. You are imagining and evolving a sculptural idea, but the two are not contrary activities, not to me.'[*]

Moore tells the story of his involvement with the sheep theme in the comments he provided for the *Sheep Sketchbook*, a facsimile published in 1980 of the original made in 1972. The period of packing his work for the Florence Exhibition of that year gave him the freedom to concentrate on a subject that had always been dear to his heart – 'If the farmer didn't keep his sheep here, I would own some myself, just for the pleasure they give me.' From his small maquette studio in the grounds of Hoglands he had observed their behaviour, begun to draw them, and gradually realized that 'each sheep had its individual character'. They ceased to be 'the rather shapeless balls of wool with a head and four legs' of the initial sketches. We note a technical

[*] From Moore's introduction to the *Sheep Album* (Gérald Cramer, Geneva, 1975).

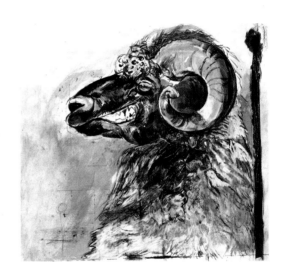

Le Bouc et l'Astrapatte Jean Lurçat, 1949, tapestry

Ram's Head Graham Sutherland, 1968 ink, gouache and crayon

progression alongside the increasing affection which he brings to the drawings, particularly of the ewe suckling her lamb (an extension to the animal world of his mother–child obsession). He devoted a month and more to drawing the sheep, singly, in pairs, grouped, standing, moving and ultimately in every stage from frisking lamb, sheep with thick fleece, to shorn sheep. The latter he thought looked so 'pathetically forlorn' that he later extended his sketchbook, which he had originally ended with the large back view of a sheep, to include a further series of shorn studies. In fact, as our illustration (59) shows, he even returned to the shorn sheep subject ten years later.

During the intensive period of his sheep studies, and subsequently, Moore developed some of the sketches into more finished compositions: 'I was still enjoying my sheep drawing, and so I went on with it.' The first drawings were executed with ballpoint pen – a miraculous tool in Moore's hands – sometimes with a touch of colour wash. His increasing interest in the etching process led him to translate many of the sheep sketches into etchings, which he drew directly with the etching needle on the prepared copper plate. Later he also did a number of lithographs in which tone was as important as line.

The first *Sheep* sculpture of 1960 (68) is a fine example of the sculptor's liking for squareness: this box-like version with its strong 'primitive' head shows how effectively Moore has assimilated the spirit of sculpture observed in such collections as the British Museum or the Musée de l'Homme in Paris. The decision to cast the plaster of the *Sheep* sculpture in bronze was made in 1968, the year preceding the etchings *Projects for Hill Sculpture* 1969, which led up to the *Sheep Piece* of 1971–2 (71). In the drawings, etchings, maquette and working model for this huge bronze there is from the start a promise of the authoritative certainty of the final sculpture. Even the important flange-like ridge – so necessary, we realize, to break the vast rising curved surface of the large 'mounting' piece – and the table-form are already anticipated in the 1969 etching. So we follow the stages from a plaster maquette of 14 centimetres, through the working model of 1971, to the final, monumental *Sheep Piece*, 1.4 metres long, which was the central feature in the Battersea Park Exhibition of Sculpture in the Open Air of 1977 and a landmark in the evolution of Moore's sculpture. It is not only a summing-up of his feeling about sheep form but a piece 'just the right size for the kind of landscape setting' Moore likes, which real sheep could, as he puts it, 'play around'.

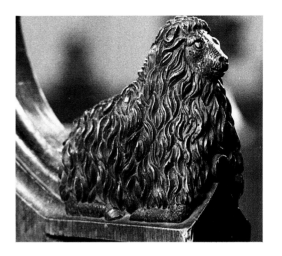

Sheep Medieval bench end, St Andrew's Church, Tostock, Suffolk

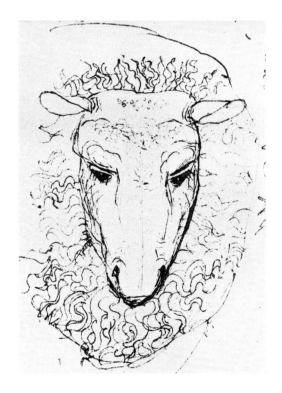

Head of Sheep Samuel Palmer (undated) Victoria and Albert Museum

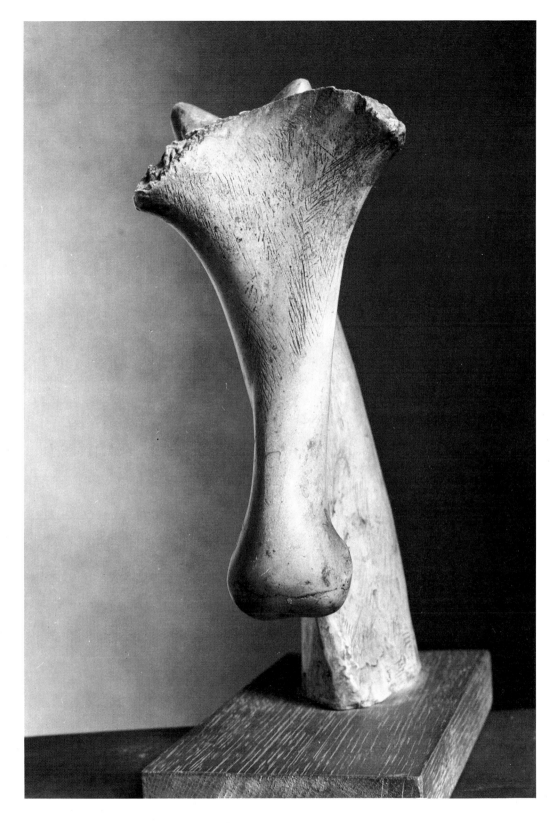

54 *Goat's Head* 1952 H 20.3cm plaster

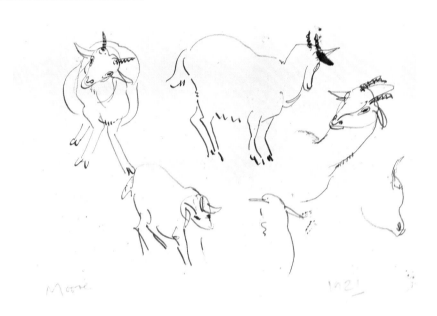

55 *Goats:* page 131 from Sketchbook 1921 17.2 × 22.2cm pen and ink

Sheep and Goats Antoine Bourdelle, *c.* 1908, pen

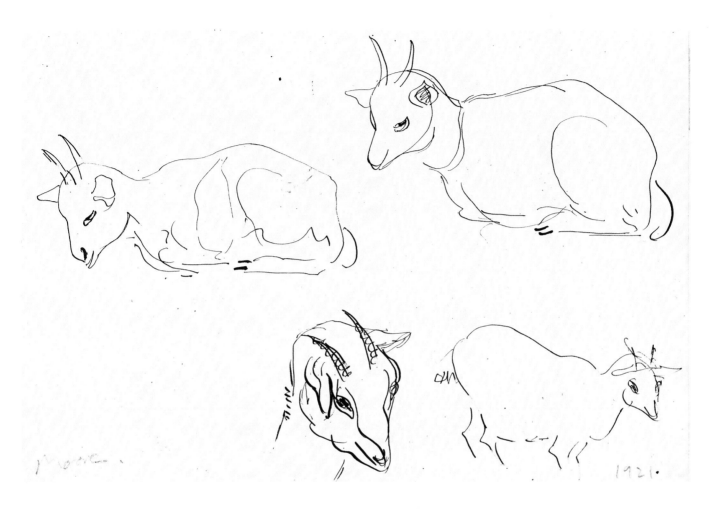

56 *Goats:* page 128 from Sketchbook 1921 17.2 × 22.2cm pen and ink

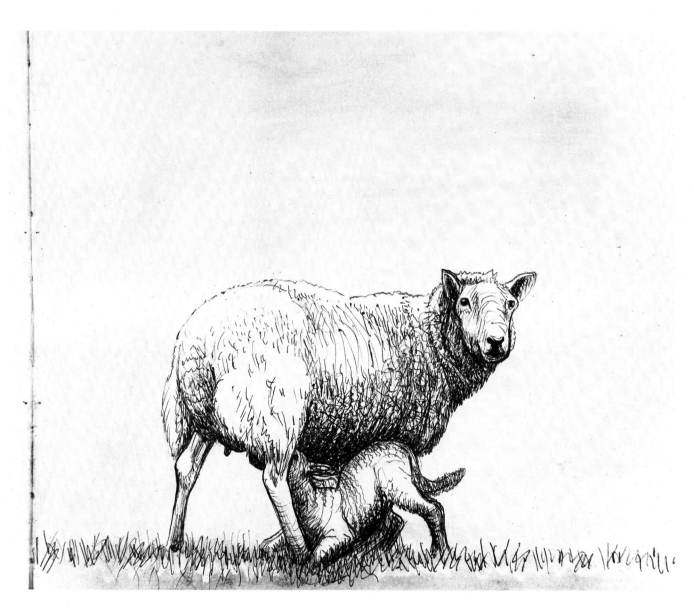

57 *Sheep with Lamb I:* page 15 from Sheep Sketchbook 1972
21 × 25.1cm ballpoint pen, crayon, wash

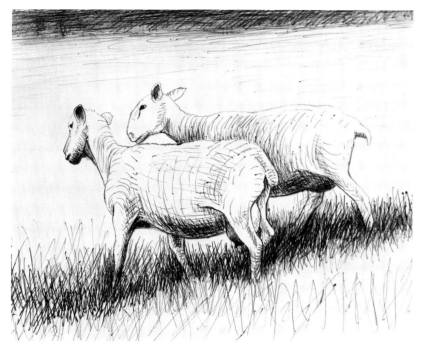

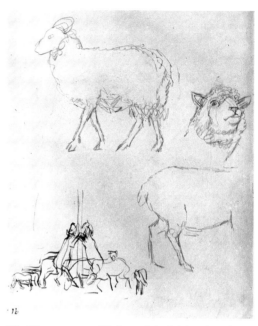

58 *Shorn Sheep:* page 47 from Sheep Sketchbook 1972 21 × 25.1cm ballpoint pen

60 *Sheep:* page 91 from No 2 Notebook 1921/22 22.5 × 17.2cm pencil, pen and ink

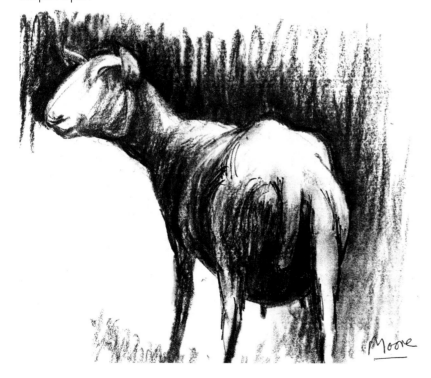

59 *Sheep after Shearing* 1982 20.9 × 24.4cm charcoal, felt-tip pen, gouache

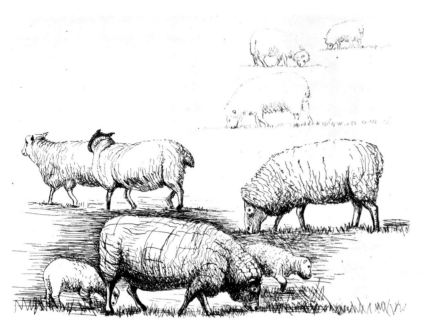

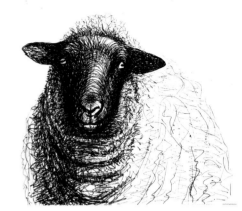

63 *Head:* page 45 from Sheep Sketchbook
1972 21 × 25.1cm ballpoint pen

61 *Sheep in Field:* page 14 from Sheep Sketchbook 1972 21 × 25.1cm
ballpoint pen, wash

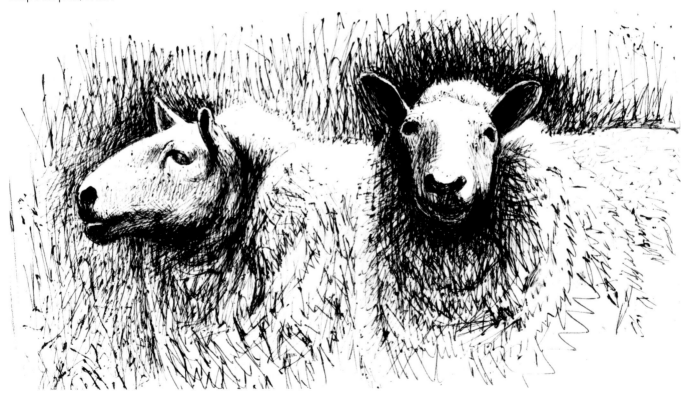

62 *Sheep before Shearing* 1974 20 × 28.2cm lithograph in two
colours, edition of 50 + 15

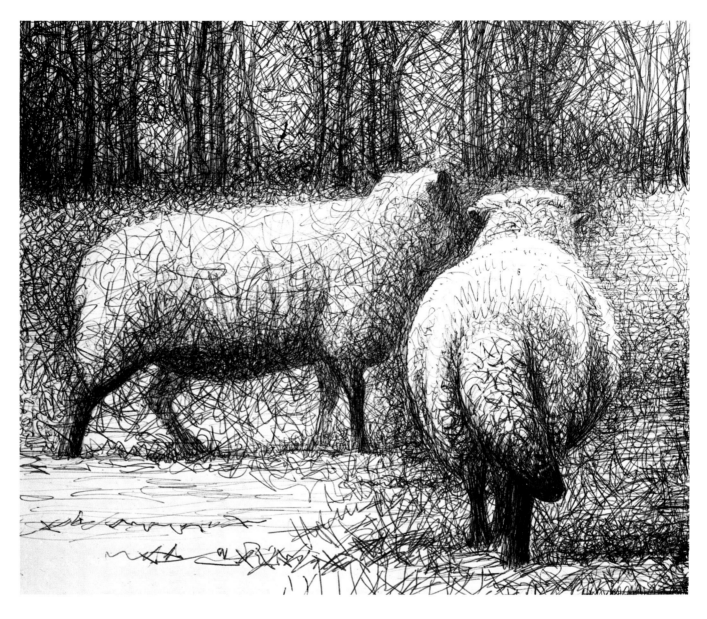

64 *Sheep:* page 38 from Sheep Sketchbook 1972 21 × 25.1cm
ballpoint pen

66 *Sheep Climbing* 1974 17.2 × 19.7cm lithograph in one colour,
edition of 30 + 10

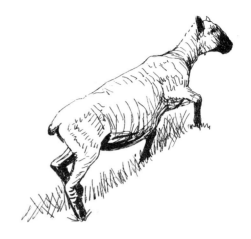

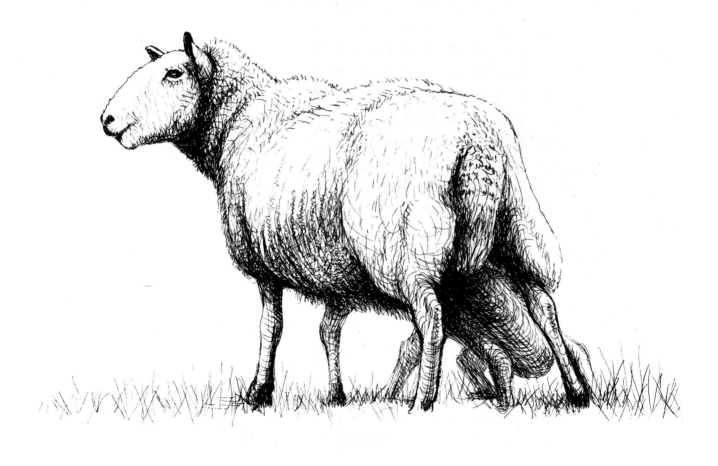

65 *Sheep with Lamb II* 1972 14.9 × 20.6cm etching and dry point,
edition of 80 + 15

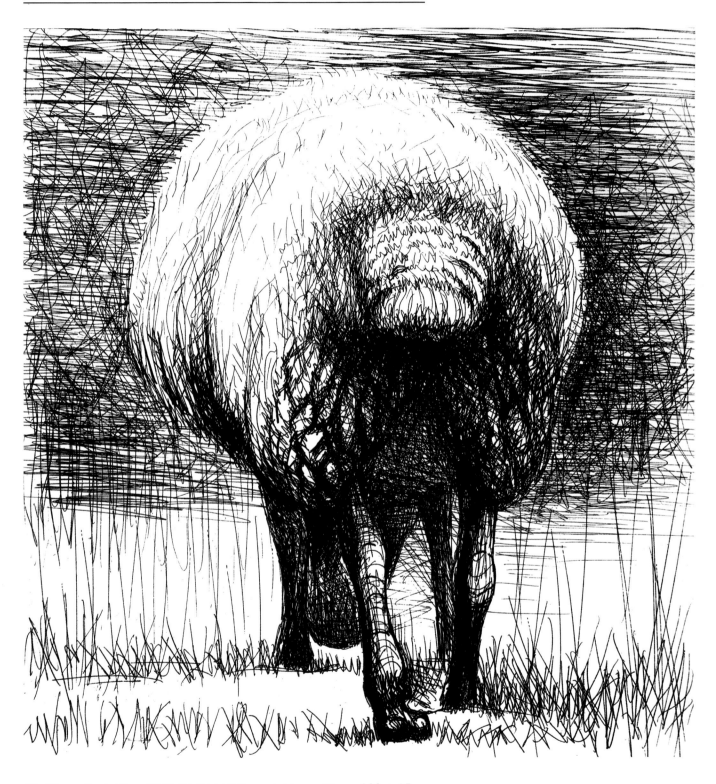

67 *Sheep Back View* 1972 21.3 × 18.8cm etching, edition of 80 + 15

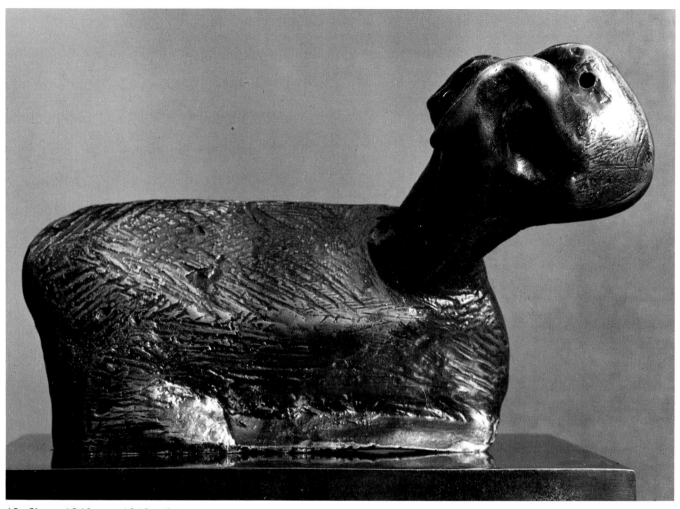

68 *Sheep* 1960, cast 1968 L 24cm bronze, edition of 9

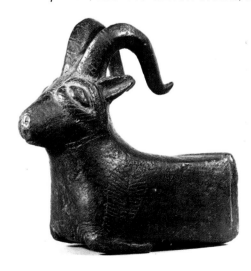

Forepart of a Goat Caucasus, 1000–8000 BC, bronze

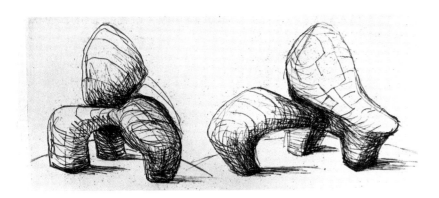

69 *Projects for Hill Sculpture* 1969 (detail) 30.8 × 24.1cm etching, edition of 100 × 35

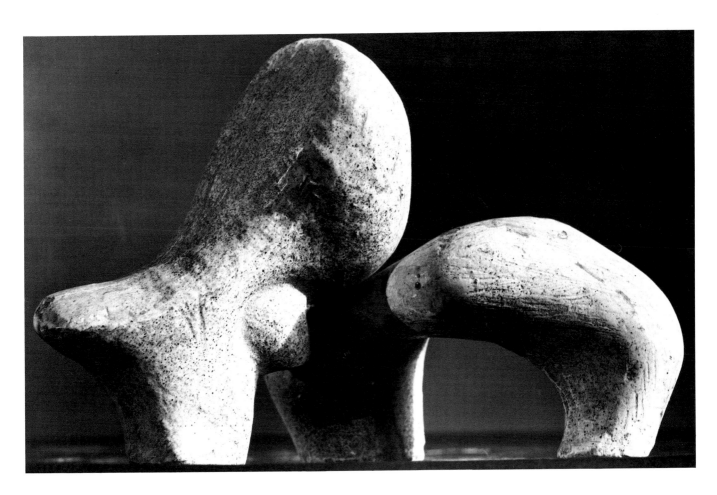

70 *Maquette for Sheep Piece* 1969, cast 1974 L 14cm bronze, edition of 7

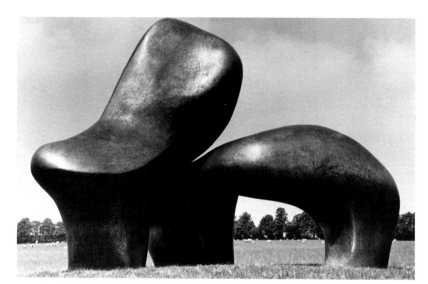

71, 73 *Sheep Piece* 1971–2 H 5.7m
bronze, edition of 3

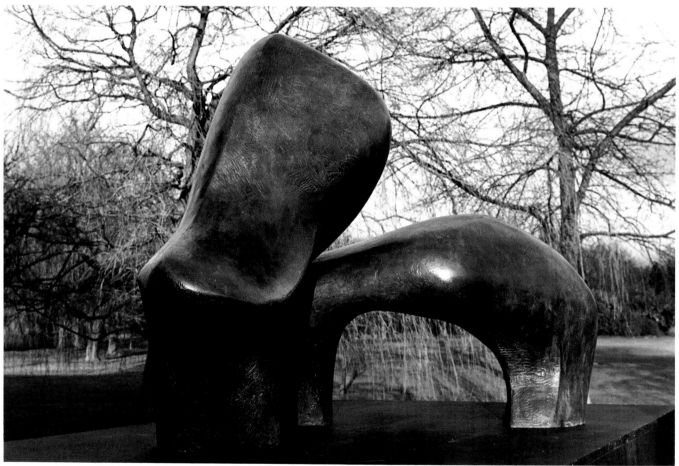

72 *Working Model for Sheep Piece* 1971 L 1.4m bronze, edition of 9

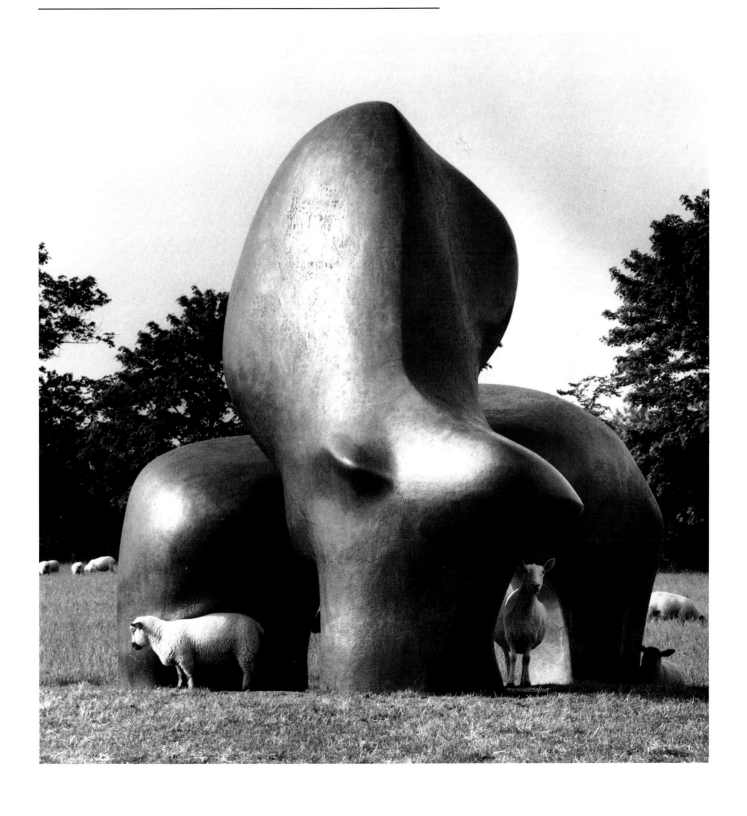

OTHER DOMESTIC ANIMALS

Without enjoying the obsessive attention Moore devoted to sheep, other domestic animals, cows, bulls, pigs, dogs and cats, have provided themes for drawings of greatly contrasted treatments, reflecting the different periods and circumstances in which they were done. We can for example compare the pen and pencil sketch of a cow (75) made during a holiday period at Stiffkey in Norfolk in 1921 with a pencil study of the same animal on a sheet of a sketchbook of 1950. The *Cow* of 1981 (76) belongs to the time when Moore was drawing a whole series of wild animals that demanded a formal, considered treatment, and involves the use of no less than seven line and tone media, whereas the bull on the sheet of mixed animals is an ideographic caricature. Again, note the difference between the chalk drawing, done from life in a neighbour's farmyard, of the languorous sow of 1953 (86) with the more elaborate version, alert and Stubbs-like, in mixed media of thirty years later.

In the two pictures – one a colour collograph and the other a free-style sketch – showing cats, the animal is a playful pretext for the mood and idiom in which Moore approached the subject. In the former the cat on the woman's lap is treated naturalistically, whereas the cat in the opposite corner is stylized, ancient Egyptian fashion, to harmonize with the portrayal of the woman.

In recent years Moore has experimented with calligraphic arabesques, transforming them into whatever his imagination prompts. The *Woman playing with kitten* (84) appears to have had such a point of departure – an elaborate flourish with a few judicious lines and touches of white wax crayon sustain the light-hearted mood.

The dog has some importance in the Moore bestiary. It is the subject of three sculptures as well as of a number of drawings. The marble carving of 1922 (79) has a compact squareness not unlike that found in some of the sculpture of Gaudier-Brzeska (*Bird swallowing a fish*, see p. 43), a language of cubist synthesis. But Moore's *Dog* is as much an individual statement as the *Snake* (1) of two years later, a taut, compact form – foreshadowed in the 1922/24 Notebook drawing of *Dog with Bone* (77). Contained aggression, as in the *Dog Fight* drawing (78), is its outward manisfestation and more in the sketch style of the sheet of mixed animals previously mentioned. The

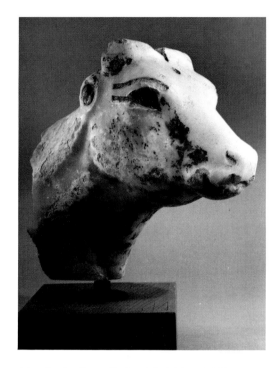

Head of a Cow Deir-el-Bahiri, *c.* 1480 BC, alabaster

drawing (82) of the sculptor's own dog Fawkes (an unclaimed stray that arrived at his house one fifth of November) captures the completely relaxed recumbent animal, and the fluidity of line also conveys a sense of a relationship. Talking about dogs, in the context of the *Dog's Head* (80), Moore commented on the animal's unquestioning loyalty and fidelity whatever treatment it received. To me the expression of the Dog bronze seemed one of alertness, but Moore observed that it also has something contemplative about it. He had noticed a similar 'thoughtfulness' in a cow's head we looked at in a Paulus Potter landscape. But he disclaimed any intention to convey this kind of feeling in the Dog's eyes: 'You don't think these things out, they happen.'

The whole essence of the *Woman and Dog* (83) is of relationship: overtly expressed in the outstretched woman's arms and the dog's head lifted towards her and, rhythmically, in the various elements of the woman's partially realized anatomy and the visual connective that we make from the tip of the dog's nose to the top of the woman's head – the eye. A triangular composition in which the intentional 'boniness' is relieved by the roundness of the woman's buttocks, echoed in the firmly planted dog. This little masterpiece transcends its diminutive scale; it is just 11 centimetres high.

74 *Animal Studies* 1950 29.2 × 23.2cm pencil

75 *Cow:* fragment page from Sketchbook
1921 12.1 × 14.7cm pencil, pen and ink

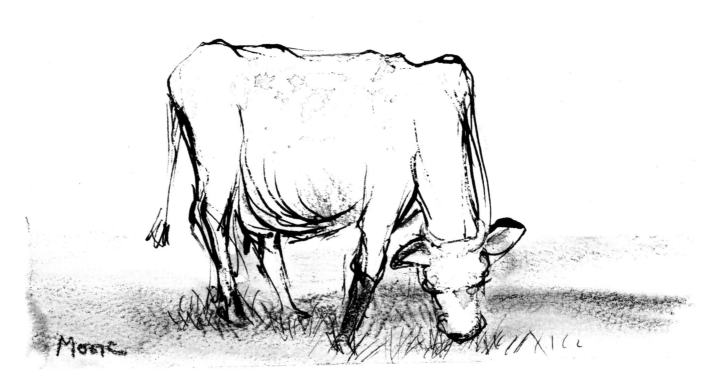

76 *Cow* 1981 17.6 × 25.3cm pen and ink, crayon, charcoal,
watercolour wash, chinagraph, ballpoint pen, gouache

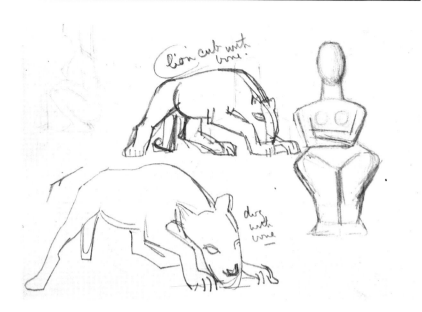

77 *Dog with Bone:* detail of page 126 from No 3 Notebook 1922/24
22.5 × 17.2cm pencil

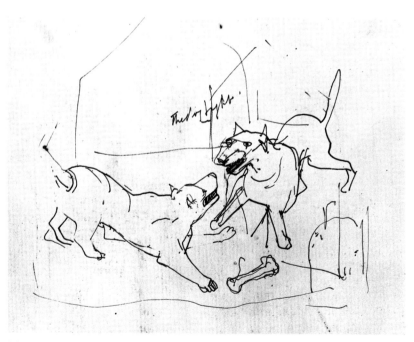

78 *The Dog Fight:* detail of page 31 from No 6 Notebook 1926
22.5 × 16.8cm pen and ink

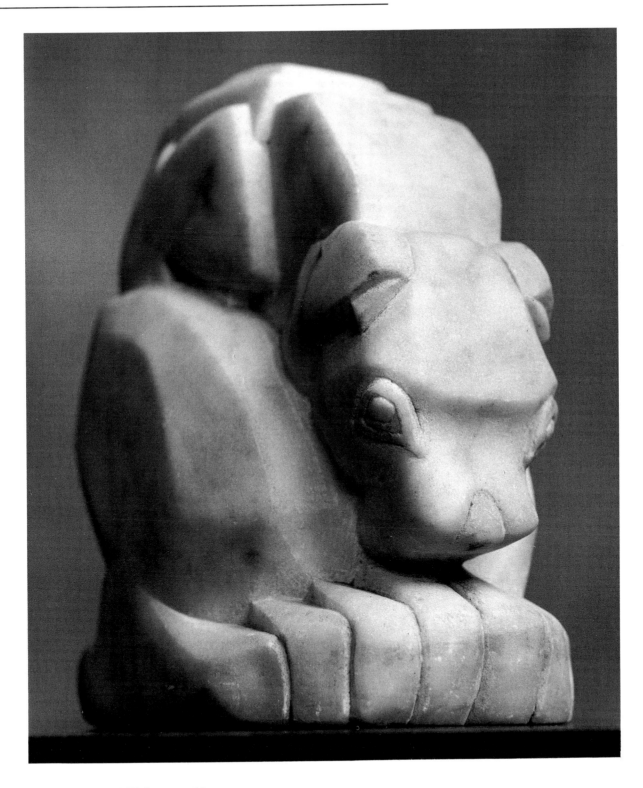

79 *Dog* 1922 H 17.8cm marble

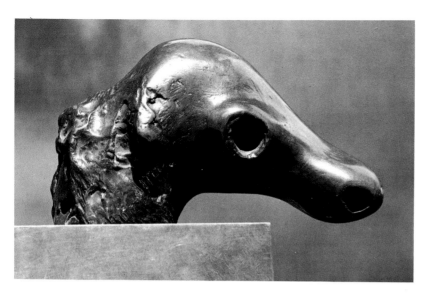

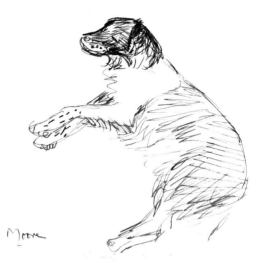

80 *Dog's Head* 1980 L 12.1cm bronze, edition of 9

82 *The Artist's Dog Fawkes:* page 70 from
Heads, Figures, and Ideas Sketchbook 1953/56
22.2 × 17.5cm pen and ink

81 *Woman holding cat* 1949 29.8 × 48.9cm collograph in four colours,
edition of 75

84 *Woman playing with kitten* 1980
26 × 18.4cm pen and ink, crayon, watercolour,
gouache, chinagraph

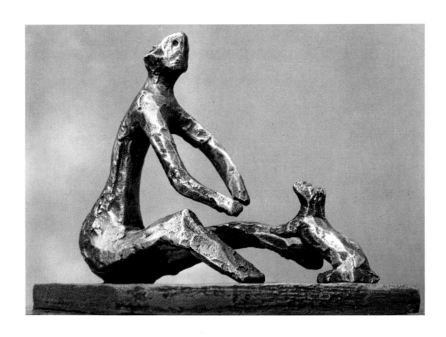

83 *Woman and Dog* 1978 H 11cm bronze, edition of 7

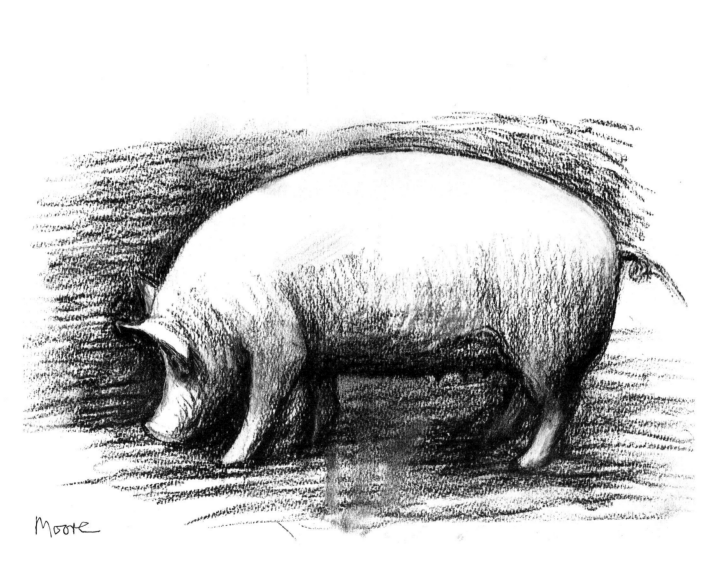

Moore

85 *Pig* 1982 25.4 × 35.5cm charcoal, pastel, ballpoint pen, gouache

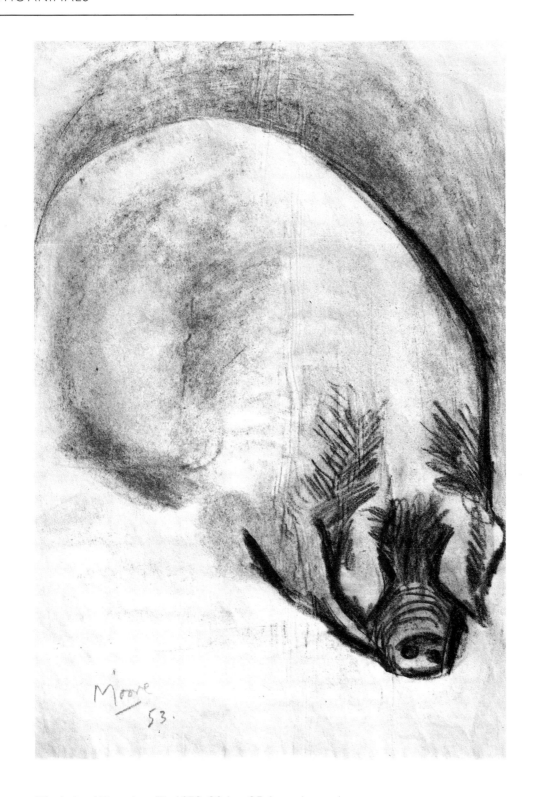

86 *Animal Drawing: Pig* 1953 38.1 × 25.4cm charcoal

4 ANIMAL FORMS

I name that man an artist who invents forms –
André Malraux

The appropriate signature for this chapter, which includes the 'bone' theme in Moore's work, is the dramatic coloured drawing *Sculptural Object in a Landscape* (87), which also contains an agreeable reference to his obsession with sheep. The drawing sums up his feeling about bone structure: 'I have always liked the shape of bones, I have drawn and studied them in the Natural History Museum . . .' In fact he knows them so well that he can invent bone forms. The examples on the sheets of bone drawings illustrated here are typical of his inventions, some of which became the basis of a 'transformation' into a more defined figure or object. The *Reclining Figure: Bone* (102) is the ultimate consecration of bone form in Moore's sculpture, as the *Sculptural Object* drawing is of his graphic treatment of the subject.

Bone forms, always an underlying element in Moore's sculpture, state their presence unequivocally in certain pieces; an actual piece of bone was incorporated in the maquette that became *Standing Figure: Knife-Edge* 1961, and the human skull is implicit in *Atom Piece* (106). But Moore's sculptures are never just one thing, and the experience of

his helmet sculptures had a role to play in *Atom Piece*. In this connection it is interesting to note that the *Interior Form* from *Helmet Head No. 5* (1966) also reminded him of a giraffe's head.

We have already noted a striking 'hard' form in the *Goat's Head* of 1952 (54). *Animal Form* 1959 (91) is a similarly hard but more complex form. This is one of the sculptor's most original small-scale creations and an extension to the spirit of the animal heads – a whole series executed during the years 1951–82. Yet its sculptural viability reconciles us to a menacing presence. The great artist, like the great writer, does not avoid expressing his subjective feelings about 'this unintelligible' world.

Not all the animal forms belong to this modality but, ignoring chronology for the moment, we see its resurgence, albeit in less aggressive and, literally, smoother shape in the *Resting Animal* of 1980 (98), a creature that is disturbingly primeval. The *Small Animal* (97) of the same year is an endearing, almost toylike creation, as simple in form with its strong arching body as the *Slave-killer club* carved on a reindeer antler by an anonymous artist in Alaska.

The two most successful animal forms expressed in bronze and carving are the *Animal Form* of 1969 (related to the *Large Slow Form* illustrated in the Reptile section on p. 31) and *Animal Carving* 1974 (92). The *Working Model for Animal Form* (94) is cast in bronze, and a carving nearly twice its length (1.2 metres) followed, in travertine marble (Plate XV). This is also the material of the final *Large Animal Form* (96), impressive on its outdoor site in the grounds of the Museum of Modern Art, New York. The square and rectilinear elements of the final sculpture lend a feeling of thrust to the whole figure which comes to such an effective climax in the reptilian head. It is one of Moore's masterpieces.

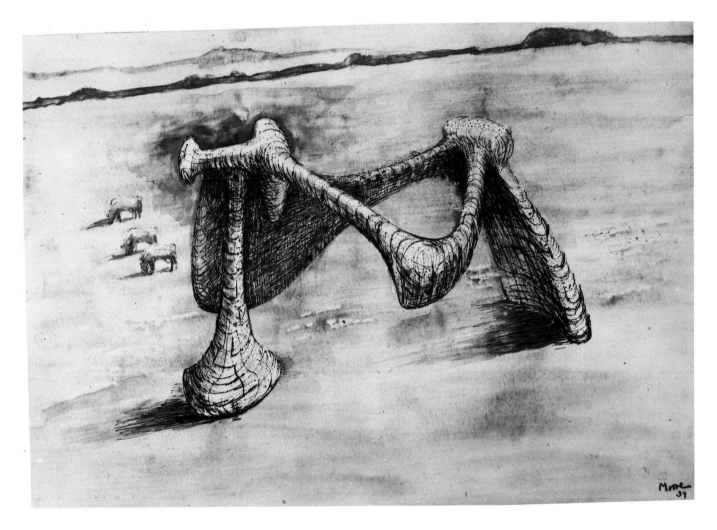

87 *Sculptural Object in a Landscape* 1939 38.1 ×55.9cm pen and ink,
crayon, watercolour

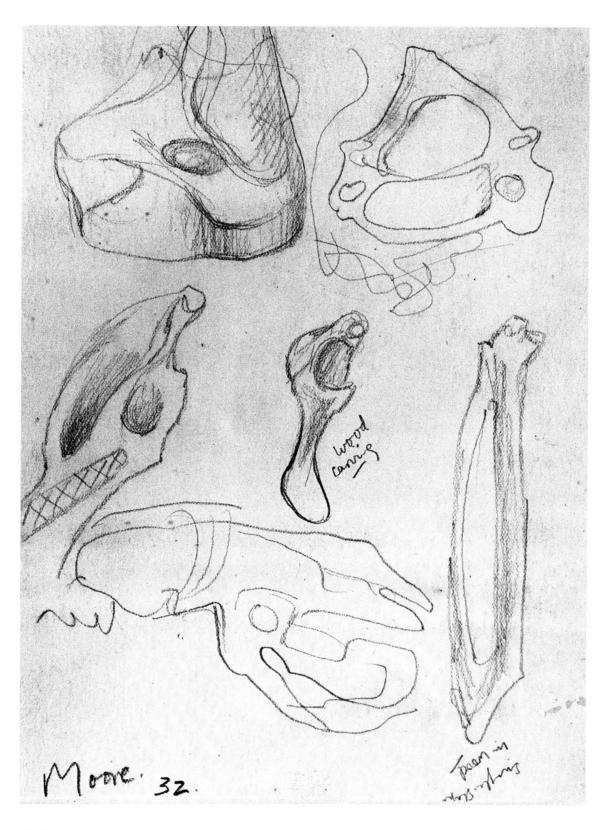

88 *Transformation Drawing: Study for Wood Carving* 1932
18.1 × 13.7cm pencil

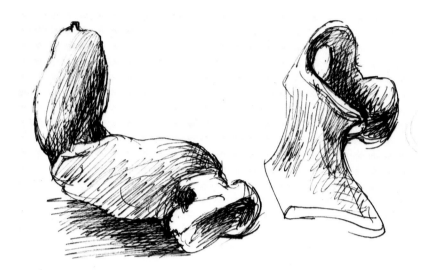

89 *Studies of Lobster Claws:* detail of page from Sketchbook 1932 27.3 × 18.1cm pencil, pen and ink

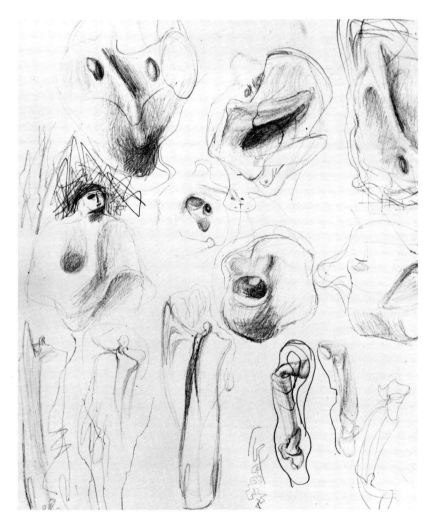

90 *Transformation Drawing: Ideas for Sculpture* 1932 31.7 × 25.4cm pencil

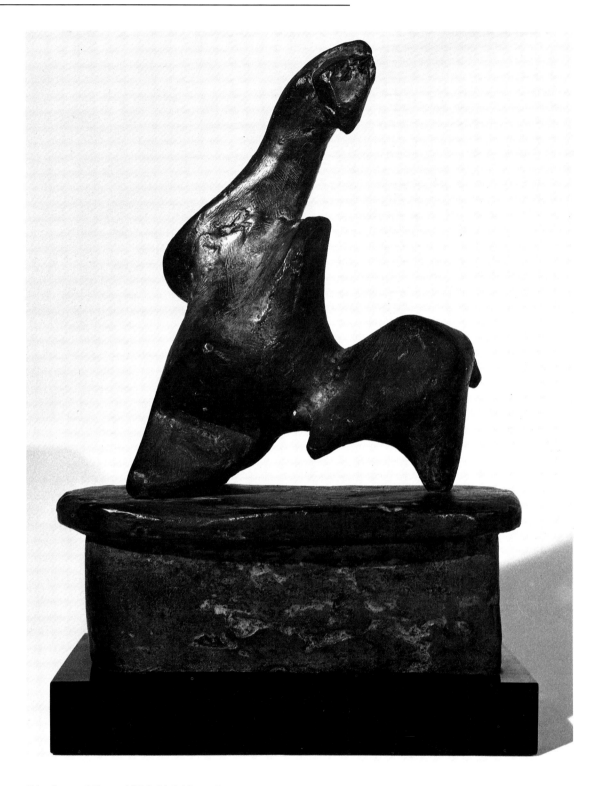

91 *Animal Form* 1959 H 34.3cm bronze, edition of 8

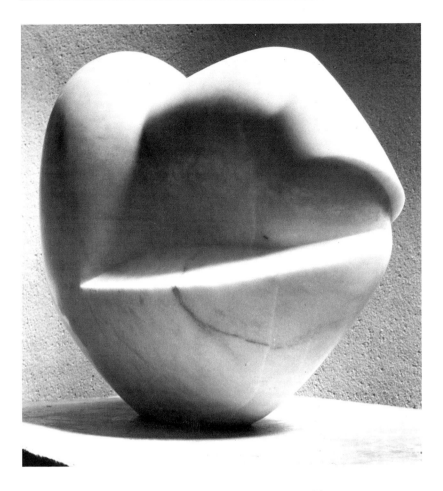

92 *Animal Carving* 1974 L 63.5cm rosa aurora marble

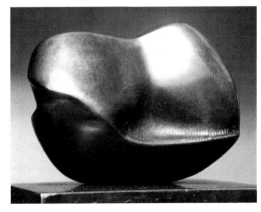

93 *Maquette for Animal Carving* 1974
L 11cm bronze, edition of 7

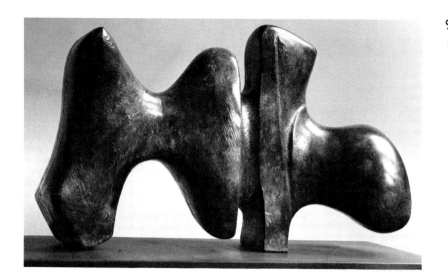

94, 95 *Working Model for Animal Form*
1969–71 L 66cm bronze, edition of 9

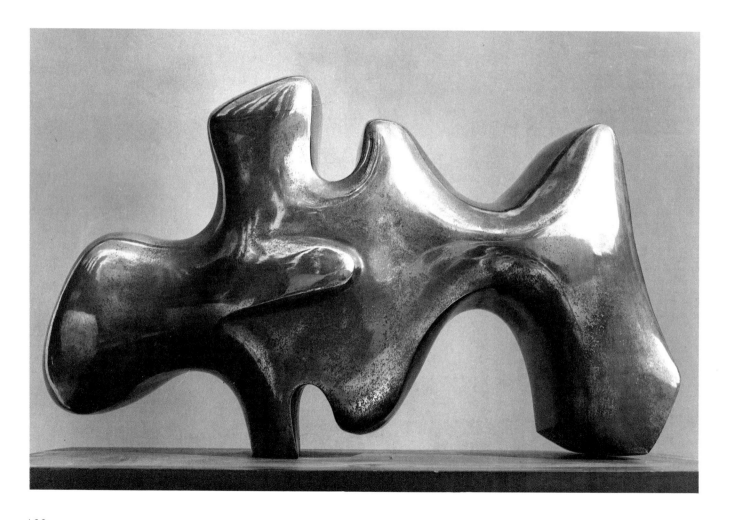

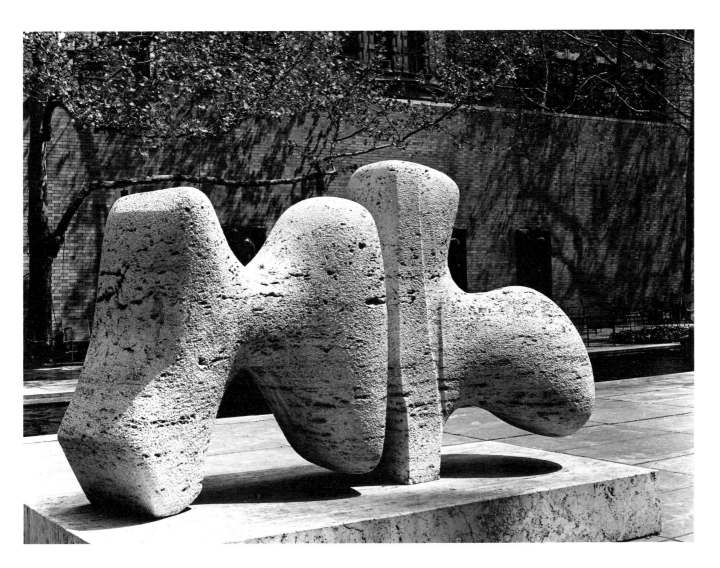

96 *Large Animal Form* 1969–70 L 2.74m travertine marble

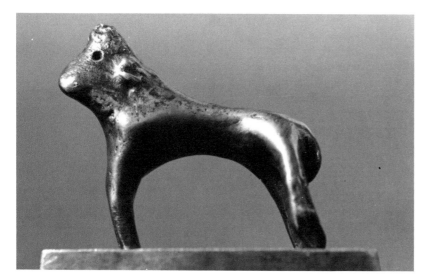

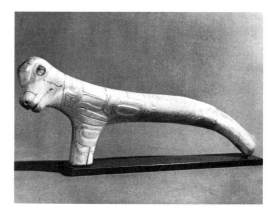

Slave-killer Club Alaska, *c.* 1800–1850
reindeer antler

97 *Small Animal* 1980 L 8.2m bronze, edition of 6

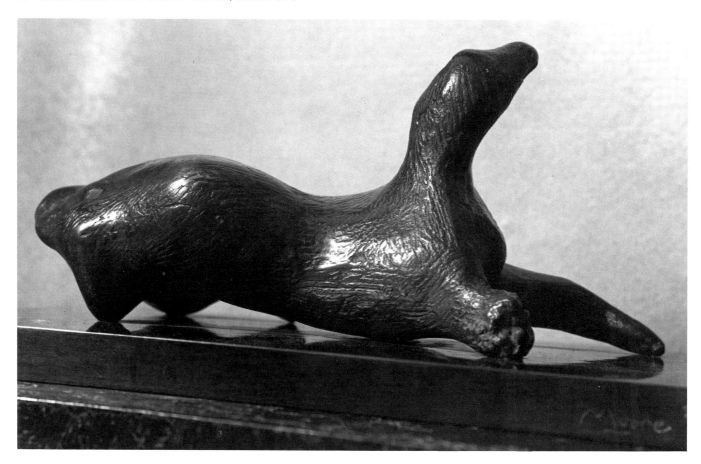

98 *Resting Animal* 1980 L 21.6cm bronze, edition of 7

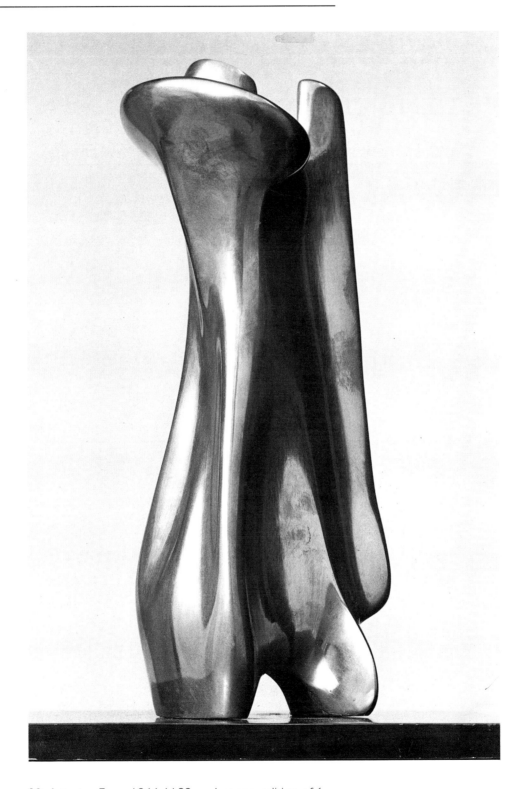

99 *Interior Form* 1966 H 32cm bronze, edition of 6

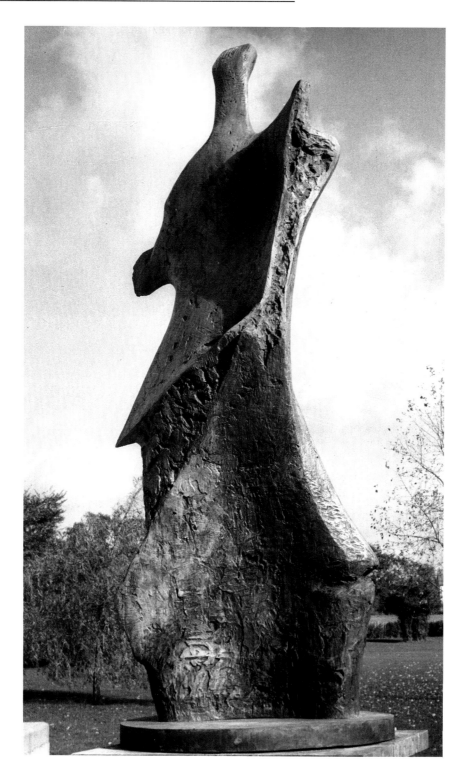

100 *Standing Figure: Knife Edge* 1961 H 1.62m bronze, edition of 7

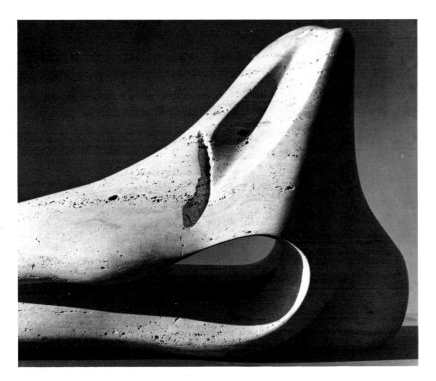

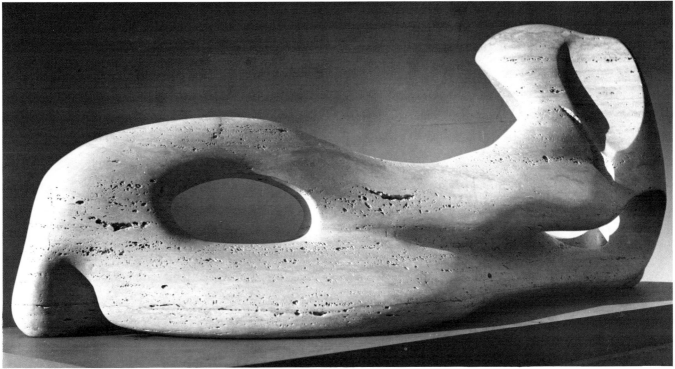

101, 102 *Reclining Figure: Bone* 1975 L 1.57m travertine marble

5 ELEPHANT AND RHINOCEROS SKULLS

*The elephant is the most remarkable living link
we have with the prehistoric world –*
Henry Moore

The elephant skull which the late Sir Julian Huxley, a Fellow of the London Zoo, gave to Henry Moore in 1968 offered the sculptor, as doubtless Huxley anticipated, more than a mere subject for descriptive drawings. It inspired a whole series of imaginative treatments of the skull and its convolutions that Moore's experienced eye saw as a potential source for exploration in all manner of ways. Between 1968 and 1970 Moore produced thirty-three etchings on the theme.

Since our special consideration here is with bone form, the etchings illustrated are those which relate to the skull as a whole rather than the more invented aspects suggested by detailed views. However, we should not be doing justice to the subject if we neglected such a variation as the etching (108) which Moore sees – and captions – as 'Head of a Cyclops', which ties up with the Fantastic heads considered in Chapter 6. Perhaps the most impressive of these etchings is the 'Skull back view' (103) – 'tunnels regressions dark depths', runs Moore's comment – corresponding to the view of the skull shown on p. 117. Two further etchings of the whole skull complete our journey

round it. The first (104) Moore describes as 'the most impressive item in my library of natural forms'. The second (105) evoked the observation quoted at the beginning of this chapter and shows an eye socket, a tusk hole and the articulation of the jaw. In several etchings we glimpse caverns full of hidden mysteries that Moore introduces us to in a structure that has 'more complexity than there is in a human skull'.

The transference of the elephant skull idea to a three-dimensional version, *Two Piece Points: Skull* 1969 (109), followed a normal Moore pattern. It was typical, too, in that it incorporated another theme, this time his recurring obsession with points, first explored in *Three Points* of 1939 and later developed in *Spindle Piece* 1968–9 and *Oval with Points* 1968–70. Two other examples, *Pointed Torso* and *Architectural Project*, belong to the same year as the *Two Piece Points: Skull* of which they are the component parts separated into individual sculptures in their own right. In this not surprisingly complicated amalgam, the initial element would seem to have come from the elephant jaws. Other perspectives are illuminated here (in the absence of multiple views) by the four angles shown in the accompanying etching (107).

After an interval of eleven years Moore returned to the subject of the skull, this time that of a rhinoceros. It was his wife Irina who thought he had, at that juncture, been drawing trees long enough and suggested he should draw the rhinoceros skull instead. This he has done with a vigorous spontaneity which a slightly less complex skull – though in all conscience difficult enough – invited. Here Moore aimed at conveying the power and concentrated bone form in the most sculptural terms possible – hence the use of tone more than pure line.

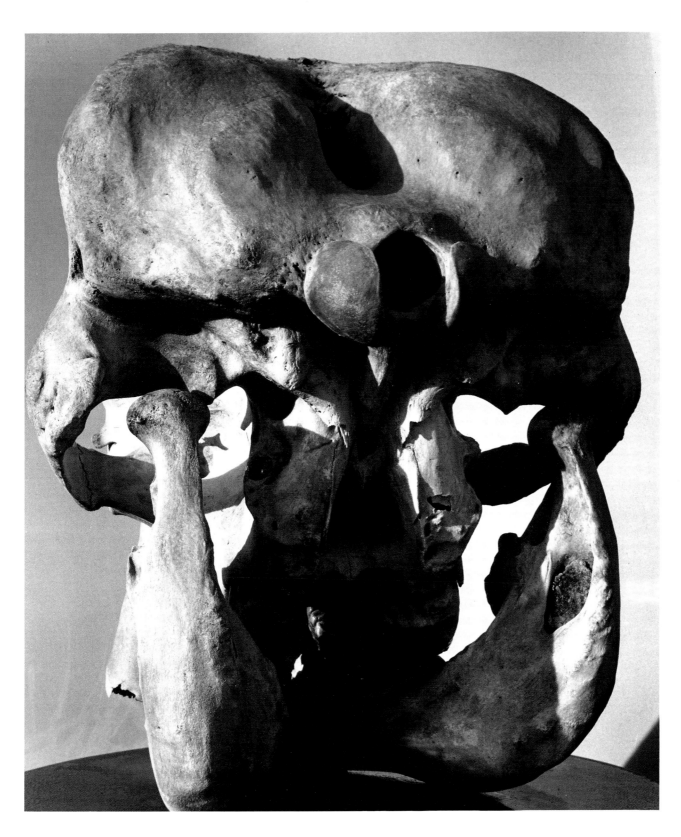

The elephant skull given to Henry Moore by Sir Julian Huxley in 1968

103 *Elephant Skull* Plate XXVIII 1969 25.4 × 20cm etching, edition of 100 + 15

104 *Elephant Skull* Plate XXIII 1969 25.4 × 20cm etching, edition of 100 + 15

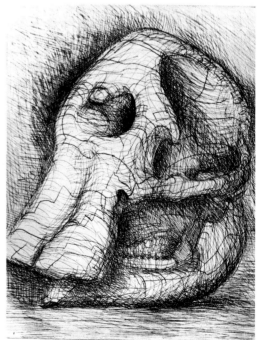

105 *Elephant Skull* Plate XVII 1969 25.4 × 20cm etching, edition of 100

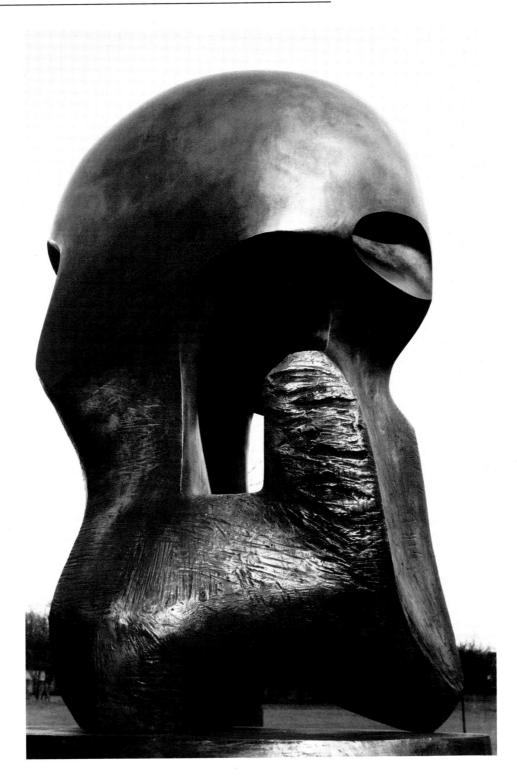

106 *Atom Piece* 1964–5 H 1.19m bronze, edition of 6

108 *Elephant Skull* Plate XVIII 1970
29.8 × 20cm etching, edition of 100 + 25

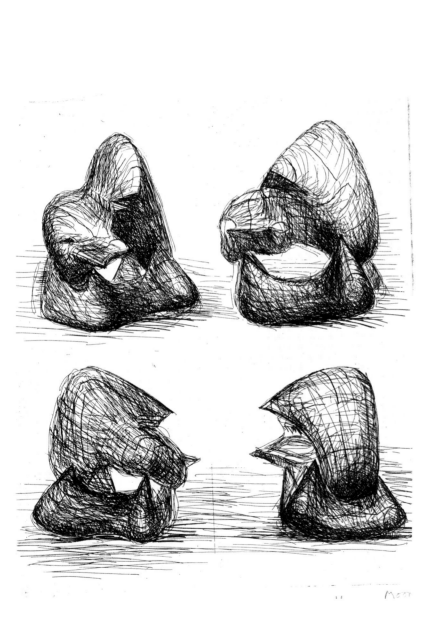

107 *Elephant Skull* Plate E 1969/70 27.6 × 23.5cm etching, edition of
15 + 5

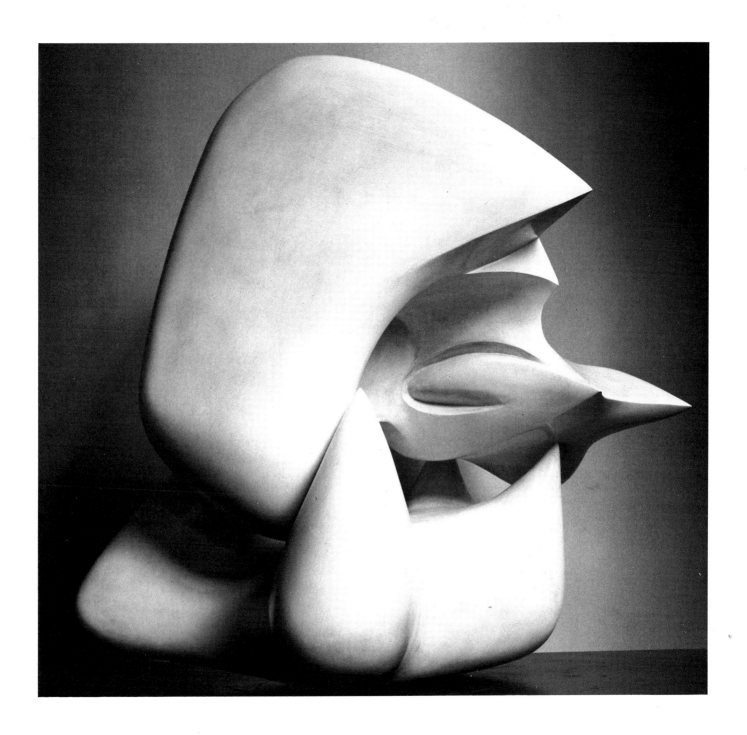

109 *Two Piece Points: Skull* 1969 H 76cm fibreglass, edition of 4

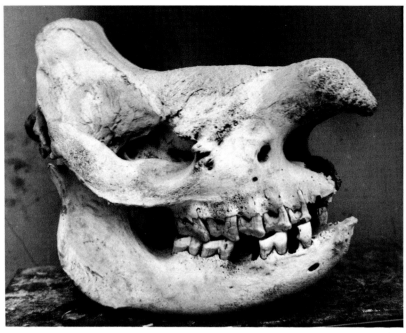

The rhinoceros skull photographed in the artist's studio at Hoglands

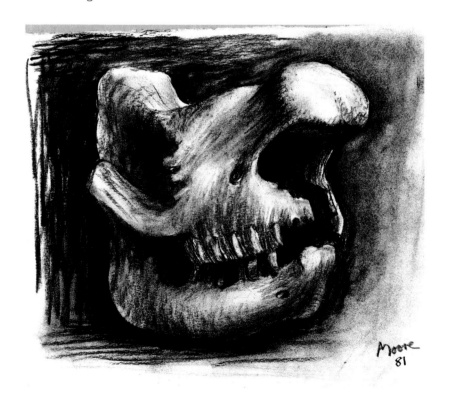

110 *Rhinoceros Skull* 1981 29.8 × 3.84cm chalk

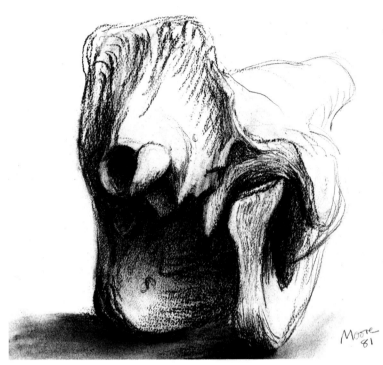

112 *Rhinoceros Skull* 1981 25.2 × 29.9cm
pencil, ballpoint pen, chalk, gouache

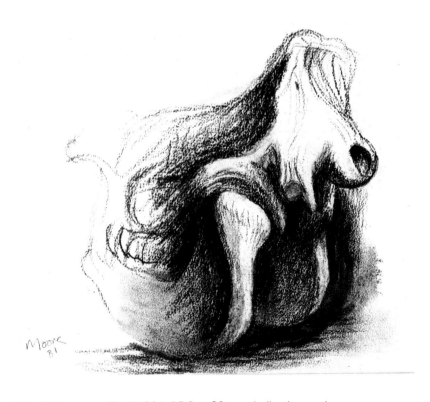

111 *Rhinoceros Skull* 1981 25.2 × 32cm chalk, charcoal

6 FANTASTIC AND FABULOUS ANIMALS

*There is one quality I find in all the artists I
admire – I mean a disturbing element of
distortion, giving evidence of a struggle of some
sort –* Henry Moore

Moore wrote 'fabulous animals' at the top of a sheet of strange
creations (132) that we would describe as 'fantastic', since we
generally reserve the term 'fabulous' for mythological beings of a more
or less universally accepted form, such as the centaur. Centaurs have
been depicted with wide variations of detail and expression, depend-
ing on the period and the civilization concerned. The walrus ivory
carved version illustrated here shows how it was imagined by medieval
eyes long before it was classicized for the second time by the
Renaissance and copied in Moore's drawing (131). This was done in
1954, shortly after his travels in Greece when for a time the classical
influence (as in the *Draped Reclining Figure* 1952-3) was dominant.
Typically, however, the Centaur appears in two variations of his own
below the copy.

These however have nothing of the awesome, even horrific element
that characterizes the animal heads on the sheet of mixed-media
drawings illustrated (132). Distorted features on bulls' and horses'
heads evoke Picasso's obsessions with these same animals. The equine
head, centre right, is in the same modality as the frightening horse's
head in the painting *Guernica* which Moore had seen, unfinished, in

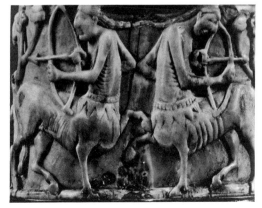

Centaurs From a design on an oval box of
walrus ivory, 12th century

Picasso's studio in 1936. Two other heads on the Moore sheet remind one of the Spanish artist's bull-fighting and minotaur themes. They express parallel moods in both artists: Picasso overtly reflecting the horrors of the Spanish civil war, Moore a general mood of angst. The pencil drawing of a *Head* (125), dated 1935, could in its predatory cruelty have been a reaction to the rise of dictatorships and the threat of war. And what hidden thought lies behind the disquieting image, the most inhuman figure, of *Man holding rabbit* (127)?

Not all the drawings grouped in this chapter stem from the same impulse. The *Bird Head* (126) of 1934, like *Bird and Egg* (19) of the same date, is of surrealist mood, while the *Lyre Birds* (124) are witty variations on the bird of the natural world. One recalls a version Moore contributed for the cover of the review *Poetry London* in 1942. The present examples were re-drawn in 1942 and 1978 and linked with Moore's square-form obsession.

The drawing on the top part of a sketchbook page labelled 'Head and Dog' (133) is a fantastic depiction of a 'young girl playing piano' which appears to incorporate the back of a ladder-rocking chair. The dog is drawn in a childlike idiom which emphasizes the light-hearted mood.

The delightful curvaceous form of the *Swooping Bird* (Plate XIX) might be adduced as an example of Leonardo 'lichen mark' inspiration referred to in the introduction. Moore had no other explanation of its genesis. It bears the date 1982, a welcome indication that Moore's vocabulary of invented forms shows no sign of diminishing, nor does the variety of graphic means in which he expresses them.

ANIMAL HEADS

The 'animal heads' – so labelled – compose some of Moore's most original and at the same time disquieting creations. They correspond to elements in a number of other sculptures, the heads for example of *Three Standing Figures* 1947–8 or that of the *Warrior with Shield* 1953–4 and a group of small bronzes made a little later such as an awesome *Head* 1955, *Mother and Child: Petal Skirt* 1955, and *Emperors' Heads* 1961.

The first *Animal Head* of 1951 (114), with its grinning skull-like form, belongs unambiguously to the sculptor's zoomorphic variations on the theme, among which, despite its title, the *Horse's Head* of 1980 (Plate XVIII) must be counted. The former is hauntingly assertive and has exercised its strange fascination in several Moore retrospective exhibitions. The *Animal Head* (116) of five years later evokes images of a primal world. The wide, 'snorting' (Moore's word) nostrils, the eye placed high on the dome of the skull give it a prehistoric appearance emphasized by the hatched texture suggesting a pachyderm.

The *Animal Head* drawing in a sketchbook of 1961–62 (119) takes us a step further into this monstrous inner world to which the only passport is our imagination – and a symbiotic understanding. This drawing, alarming but impressive, has an Aztec cruelty, whereas the mood of the lithographic *Animal Heads* of 1975 (118) is one of monumental melancholy, as if the gasping whale-like creature and the drooping, vaguely hippopotamus form are feeling doubtful of their survival in the evolutionary struggle.

The shaping of the nose in *Maquette for Animal Carving* (93), a bronze of 1974, anticipates that feature in *Dog's Head* of 1980, illustrated on p. 96. But the ear, absent in the *Dog's Head* but here weirdly exaggerated, and the raising of the eye to the top of the head – which always gives a primeval effect – has changed what Moore described as the 'contemplative' air of the *Dog's Head* into an uncomprehending wonderment. This, however, is less perturbing than the prolonged smile on the taut, subtly patinated *Horse's Head* (Plate XVIII). Whether these three-dimensional presences emanate mystery, or even, like the most recent *Animal Head: Open Mouth* (117), mindless mockery, they cannot – such is their sculpturally expressive power – leave us indifferent.

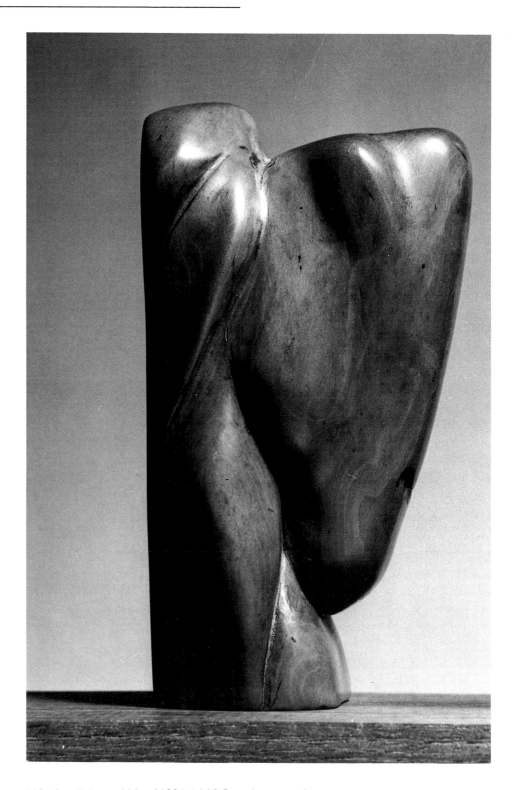

113 *Small Animal Head* 1921 H 10.5cm boxwood

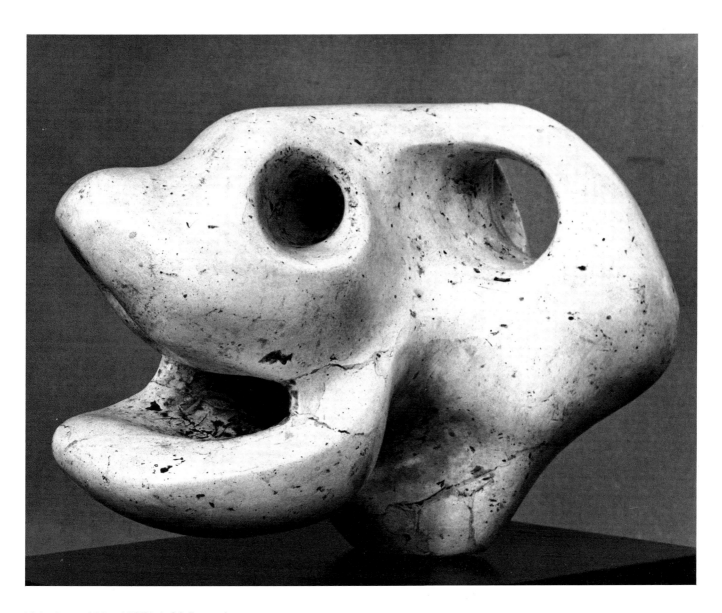

114 *Animal Head* 1951 L 30.5cm plaster

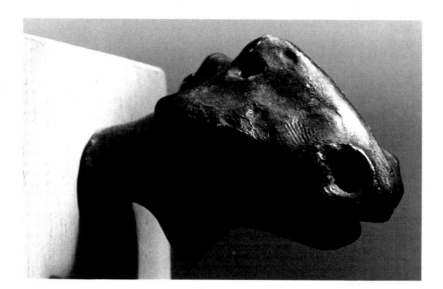

115 *Maquette for Animal Head* 1956 L 11.4cm
bronze, edition of 9

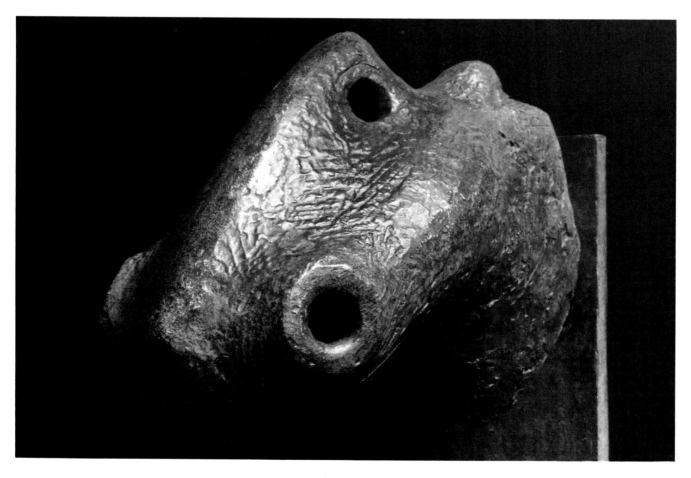

116 *Animal Head* 1956 L 55.9cm bronze, edition of 10

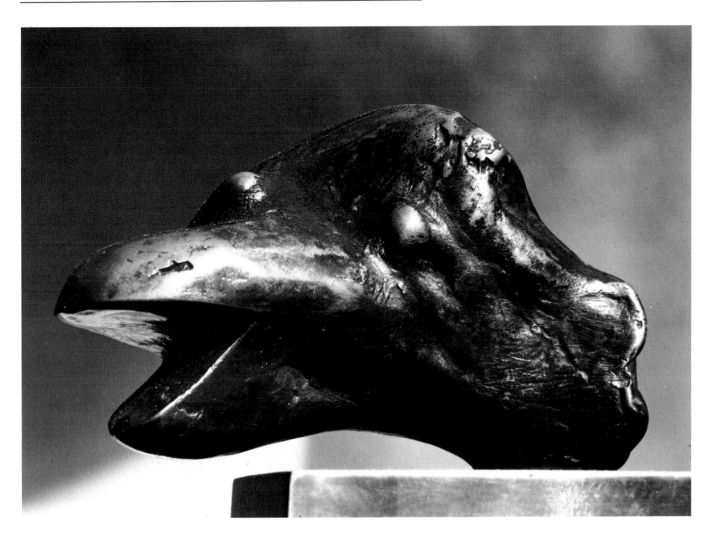

117 *Animal Head: Open Mouth* 1982 L 8.9cm bronze, edition of 9

119 *Animal Head* 1961 Page from Sketchbook 1961/62
29.2 × 24.2cm pencil, crayon, watercolour

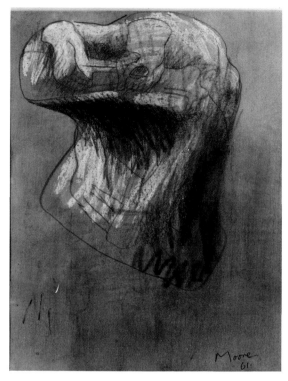

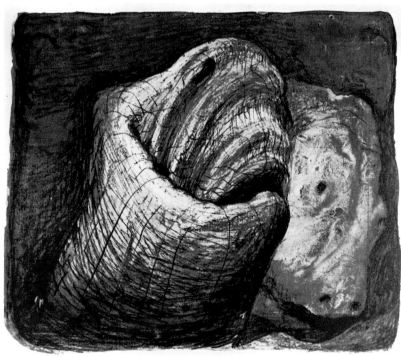

118 *Animal Heads* 1975 21.6 × 26.4cm lithograph in four colours,
edition of 50 + 15

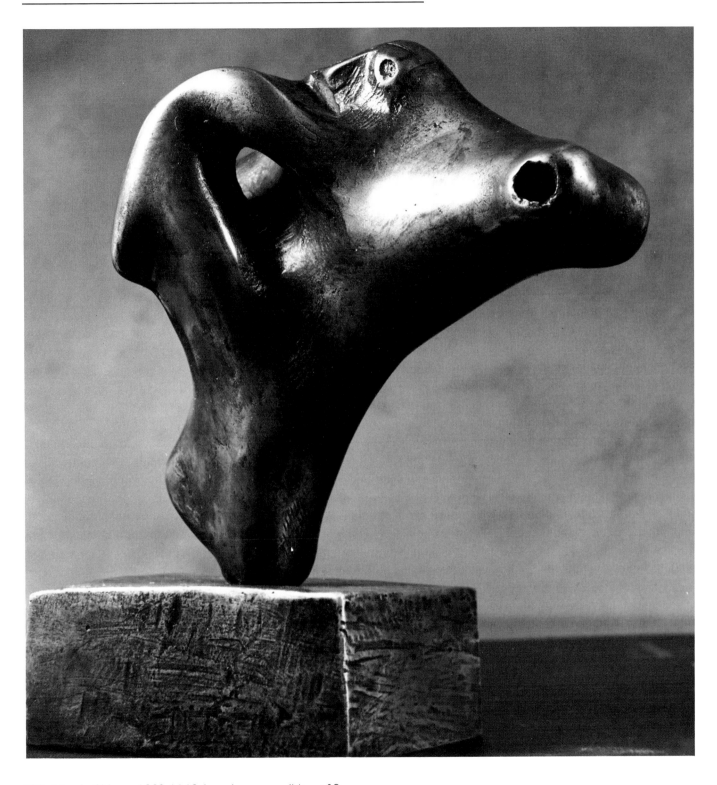

120 *Head of Horse* 1982 H 12.1cm bronze, edition of 9

FANTASTIC AND FABULOUS

The animal heads might well belong to such a fantastic creature as the *Headless Animal* (128), an invented and disturbing bronze of 1960 – the year of *Two-Piece Reclining Figure No. 2* – and a reminder of Moore's persistent duality. The note of mystery is sustained in the strange bronze of the following year, *Three Quarter Figure* (130). Moore commented: 'It is rather like a hippopotamus, and reminds me of some white plaster casts of seated figures from the paleolithic period in the British Museum.' This *post hoc* rather than *propter hoc* explanation is a tacit acknowledgement on the sculptor's part of the unconscious element that finds its way into these strange creations. The other *Animal* (129), an equally satisfying sculptural form, could be one of those exotic artefacts found in ethnological museums that Moore so admires.

Before considering the drawings grouped, despite their diversity of mood, under the heading Fantastic and Fabulous, a most important carving of a lynx owned by Moore demands our attention (p. 137). Probably of ancient Persian origin, it is an established favourite in the Moore household. Transcending ordinary descriptive animal sculpture and capturing the agile strength of the rather ambiguous feline, it is a marvellous work of art in its own right and has inspired Moore to do a number of drawings. In one (121) he portrays the animal's litheness in linear terms, in another (123) he concentrates on its compact power and in a third, a detail of the head (122), he conveys the ferocious character, summed up in the snarl and bared teeth.

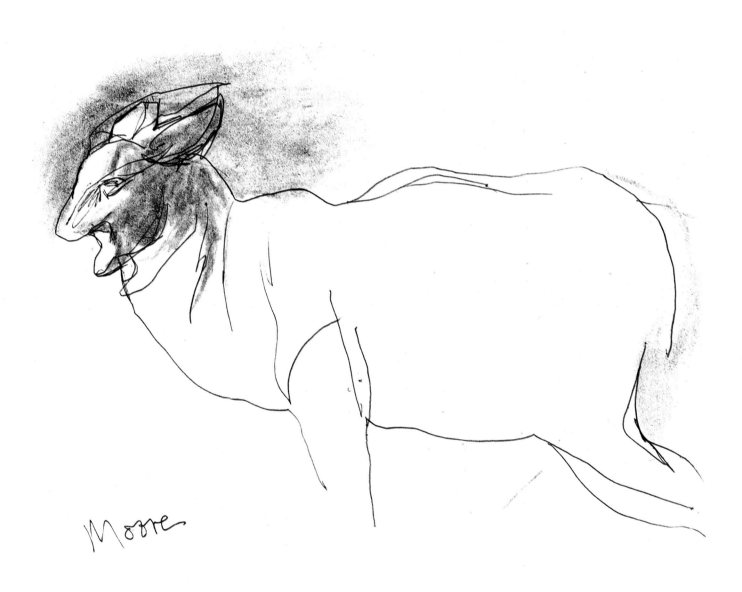

121 *Lynx* 1982 19.5 × 24.8cm ballpoint pen, charcoal

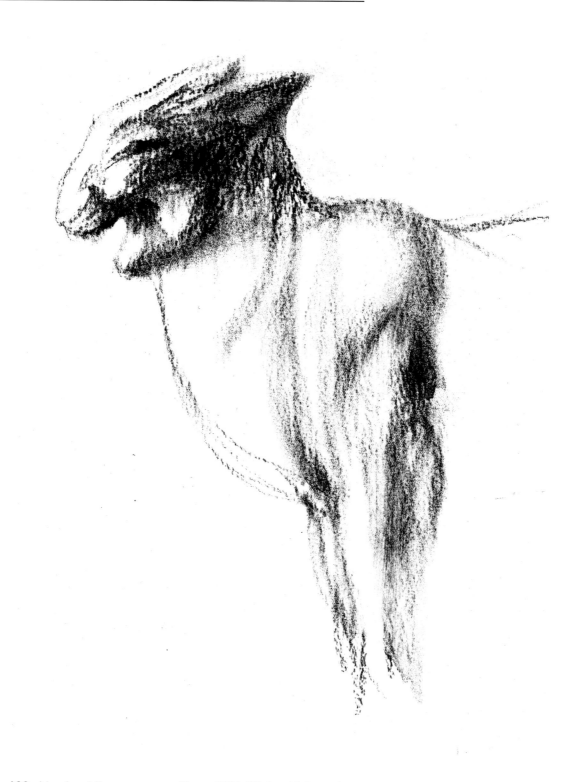

122 *Head and Forequarters of Lynx* 1982 25.4 × 19.9cm charcoal

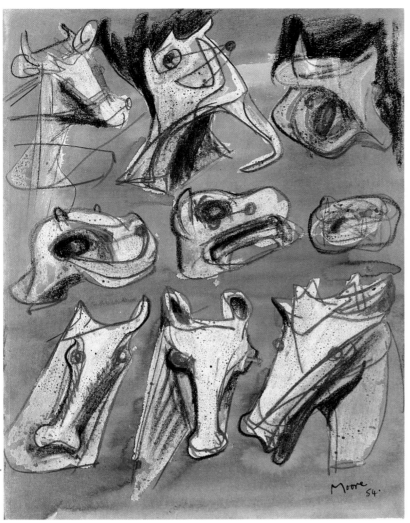

XIII *Animal Heads* 1950 36.2 × 29.8 chalk, crayon, watercolour

'I often make drawings directly from nature, but I also enjoy inventing my subjects.' Compare the three equine heads on the bottom row with the drawing after Ghiberti (52) – an interesting return to an earlier treatment.

XIV *Cow* 1982 17.6 × 25.3cm pen and ink, crayon and charcoal, watercolour wash, gouache, chinagraph, ballpoint pen

'In some of my drawings I have used imaginary sectional lines, going down and across forms to show their shape without the aid of light and shade.'

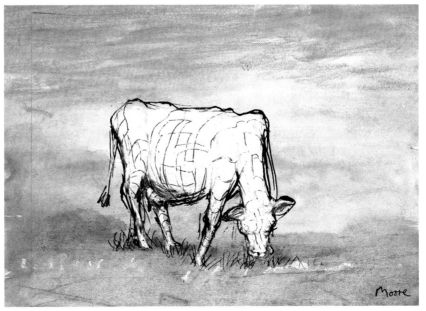

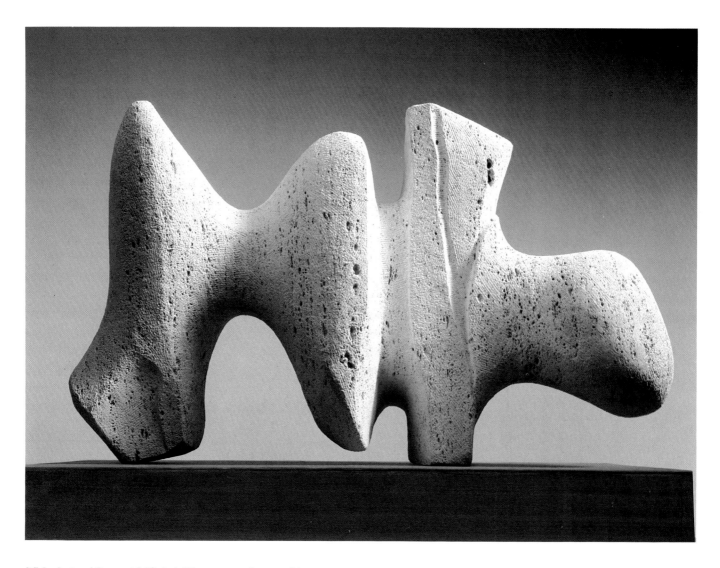

XV *Animal Form* 1969 L 1.22m travertine marble

A compact form enhanced by the attractive graininess of the
travertine marble. There is a suggestion of movement in the section
not quite touching the ground.

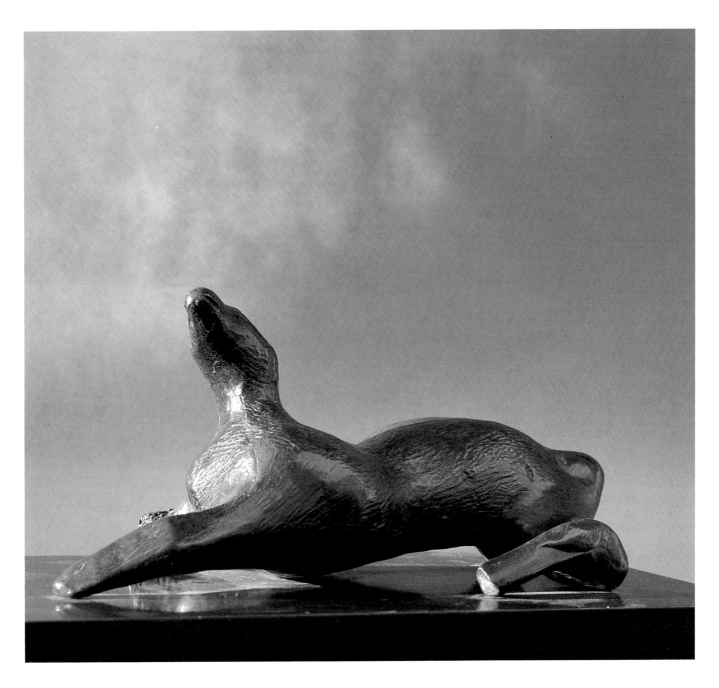

XVI *Resting Animal* 1980 L 21.6cm bronze, edition of 7

This ambiguous creature seems to have emerged, bewildered,
from a primeval world.

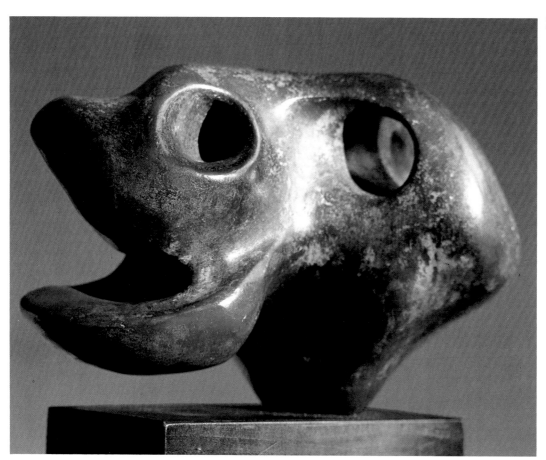

XVII *Animal Head* 1951 L 30.5cm bronze, edition of 8

Compare this grinning skull-lik form with the no less menacin smooth-fleshed head below.

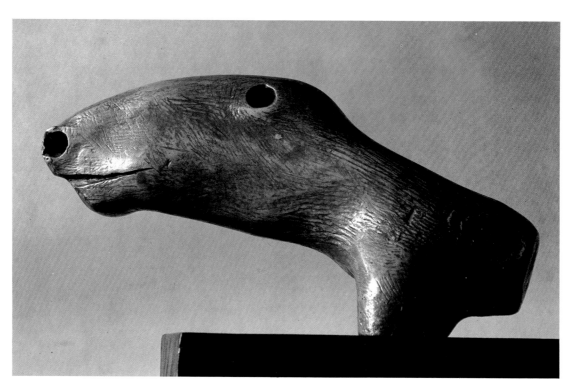

XVIII *Horse's Head* 1980 L 19.7cm bronze, edition of 7

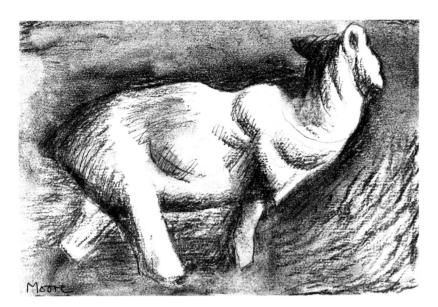

123 *Study after Lynx* 1982 17.7 × 25.4cm
carbon line, charcoal, ballpoint pen

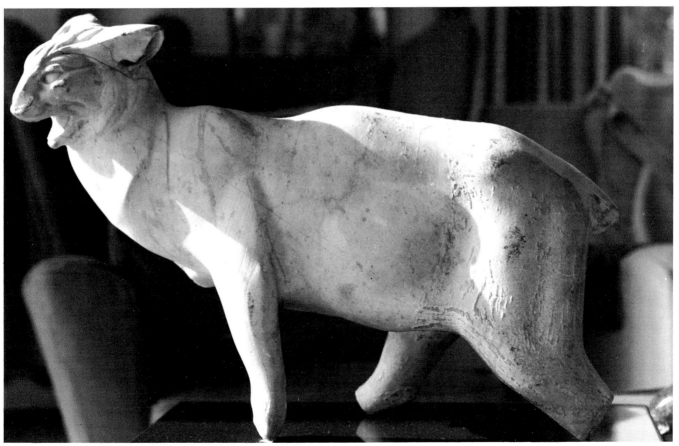

Lynx Persian, 3rd century BC, marble

124 *Square Form Lyre Birds* 1936 (redrawn 1942 and 1973): page from Sketchbook with Square Forms and Lyre Birds 25.7 × 17.8cm chalk, wash, coloured ink

125 *Animal Head:* detail of page 45 from Sketchbook 'B' 1935 21.6 × 14cm pencil, chalk

127 *Man holding rabbit* 1954
16.5 × 13.3cm pen and ink

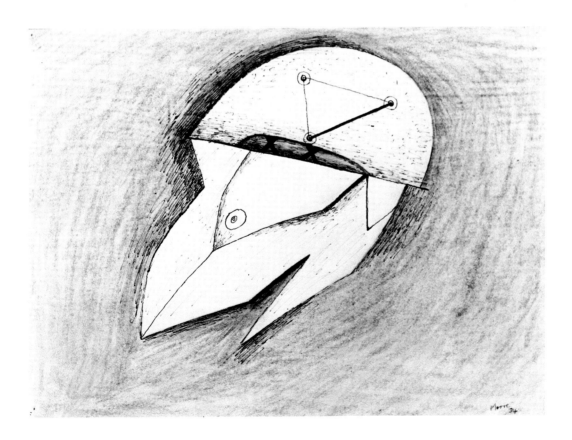

126 *Bird Head* 1934 27.3 × 37.5cm pen and ink, chalk, wash

128 *Headless Animal* 1960 L 24.1cm bronze, edition of 6

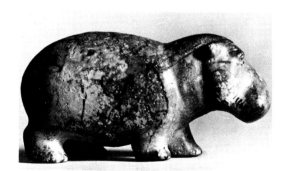

Marching Hippopotamus XII Dynasty
(Egyptian) *c.* 1880 BC, faience

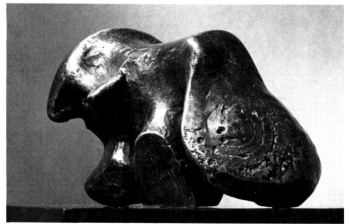

129 *Animal* 1975 L 19cm bronze, edition of 7

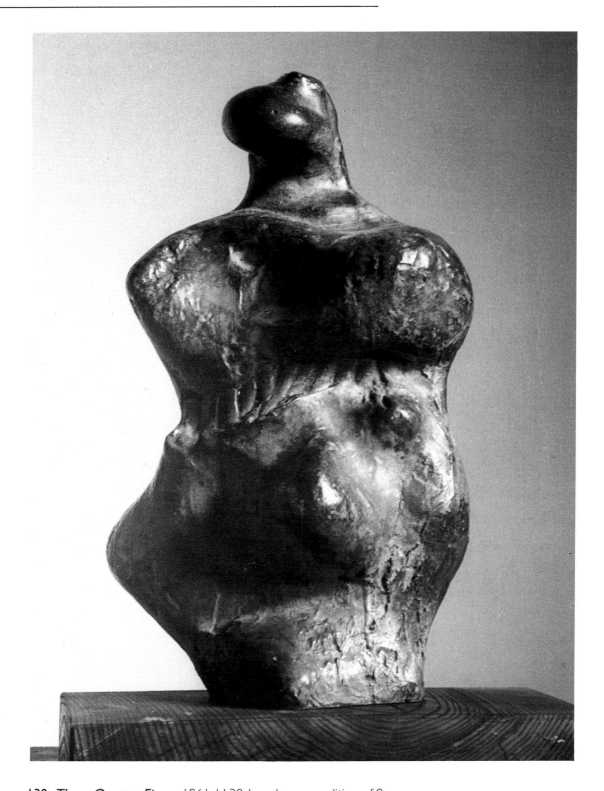

130 *Three Quarter Figure* 1961 H 38.1cm bronze, edition of 9

131 *Centaurs* 1954 29.2 × 24.1cm pencil

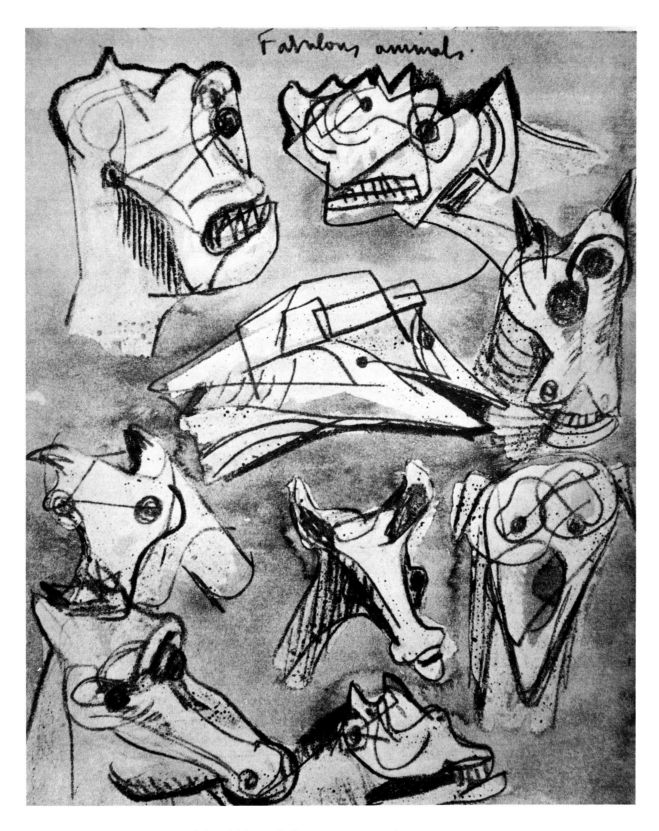

132 *Fabulous Animals* 1950 29.2 × 24.2cm chalk, crayon, watercolour

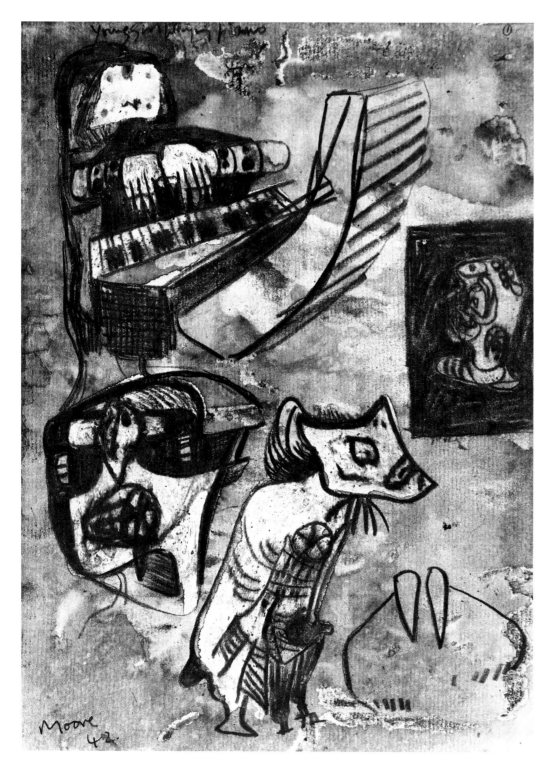

133 *Girl playing piano: Head and Dog* 1942 22.2 × 16.5cm crayon, wash

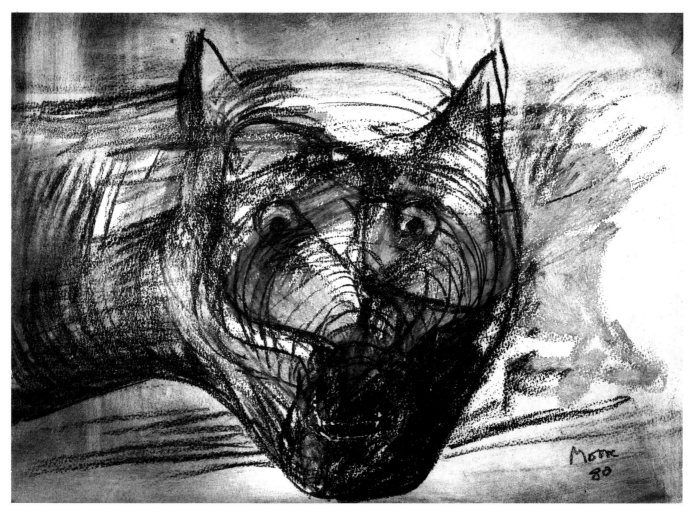

135 *Animal Head* 1980 25.2 × 35.5cm
wash, charcoal, wax crayon, gouache,
felt-tip pen

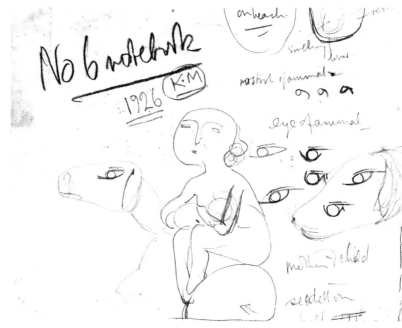

134 *Detail of inside cover page from
No 6 Notebook* 1926 22.5 × 16.8cm pencil

SHUT-EYE DRAWINGS

'Shut-eye' drawings is Moore's own term to describe the kind of drawings he and other art students used to execute with their eyes closed. As Moore explained, the artist having no model must rely entirely on his memory of form. This eliminates the accidental and also trains the hand to execute a drawing rapidly and – since his vision cannot guide him – to complete the work in an almost unbroken line.

The drawings also have a playful side, as we note from the subjects chosen; most of them, done in later life with his grandson in mind, are of animals. The zoo animals are a diverting corollary to the serious Zoo or Wild Animal series. In order to emphasize this relation and to differentiate them from the other kinds of drawings represented in this book, it seemed preferable to allow the *scherzo* to precede the weightier movement.

The selection here shows two 'shut-eye' single subject drawings and two mixed pages on a miniature scale – almost calligraphic notations. The *Leaping Lamb* (137) and the *Racehorse* (136), the latter scrupulously captioned by Moore as 'partly shut-eye', demonstrate the artist's virtuosity and his store of mental observation. Both are composed of a minimum of unbroken lines that capture movement and pose respectively.

The small drawings, exaggerating humorously the salient features of the animals, from mouse to lion on one sheet, from giraffe to frog on the second, reveal a personality at ease with people and particularly happy and genial with children, for whose benefit and delectation he has written the animals' identities.

136 *Racehorse* 1982 17.6 × 25.4cm stabilo pen, gouache

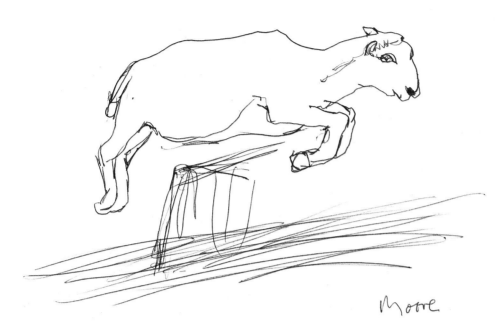

137 *Leaping Lamb* 1982 18.5 × 22.9cm ballpoint pen

138 *Animals* 1981 21.5 × 37.9cm ballpoint pen

139 *Animals and man climbing a ladder* 1981 27.9 × 29.4cm ballpoint pen

7 WILD ANIMALS

The observation of nature is part of an artist's life, it enlarges his form knowledge, keeps him fresh . . . and feeds inspiration – Henry Moore

Moore's interest in wild or zoo animals goes back at least to the childhood of his daughter Mary, whom he often took on visits to Whipsnade and London Zoo. Later, thanks to his close friendship with the late Sir Julian Huxley, Moore would go to the London Zoo on members day to observe animals at leisure. In 1981 he embarked on a portfolio of animal etchings based on drawings made recently in the London Zoo, for which the present director, Lord Zuckerman, has written the introduction.

The drawings here are of particular interest, demonstrating Moore's effective use of many different combinations of drawing tools and tonal methods.

As for the animals treated, the illustrations that follow tell their own story so I shall do no more than call attention to the portrayals which seem to me to be most successful. Not surprisingly, in view of their striking form, the elephant, the rhinoceros and the bison. Nor is it a mere coincidence that two Old Masters whose work in this genre Moore most admires, Dürer and Rembrandt, responded to the same

Leopard I Henri Gaudier-Brzeska (undated), ink

appeal with in one case a wood engraving and in the other a black chalk drawing.

Discussing wild animals, Moore said he aimed at bringing out the particular characteristic that has enabled the species in question to survive: the elephant's power and strength, the agility of the felines – tiger, leopard, jaguar – the grace of the antelope, the predatory power concentrated in the vulture's beak. One notes Moore's use of sectional line in his drawing of the rhinoceros (153) that corresponds to the armour-plating effect of Dürer's famous woodcut, and the emphasis in the tonal drawing of the animal's sheer bulk to support that fearsome horn. Similarly Moore conveys the hostile potential of the rhinoceros, the uncertain temper of the zebra. The elephant whose slow power attracts him he draws with particular affection.

In these days of safari parks and a more enlightened attitude to wild animals and the protection of endangered species, Moore's drawings, over and above their aesthetic qualities, contribute to our understanding and appreciation of the animal world.

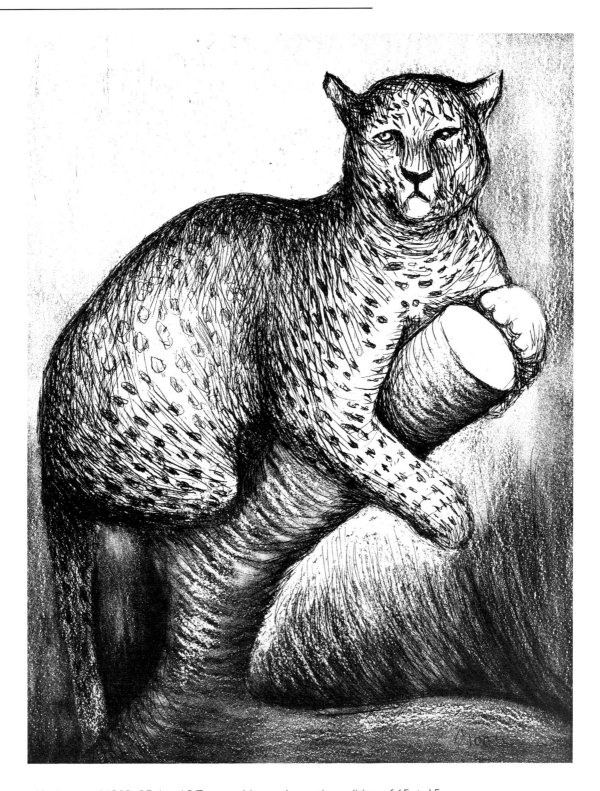

140 *Leopard* 1982 25.4 × 19.7cm etching and aquatint, edition of 65 + 15

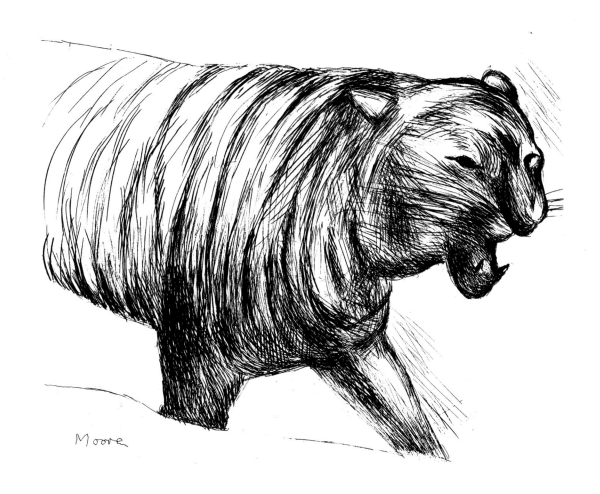

141 *Tiger* 1982 19.4 × 24.1cm etching, edition of 65 + 15

143 *Tiger* 1982 12.7 × 10.2cm etching, edition of 50 + 20

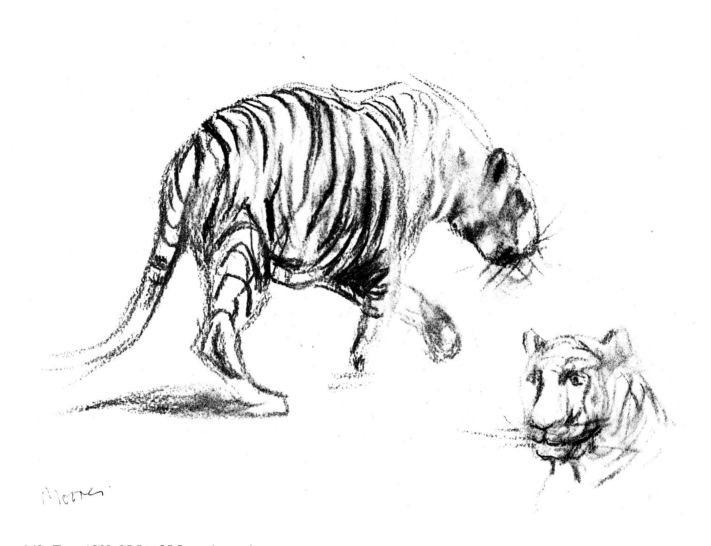

142 *Tiger* 1982 25.5 × 35.5cm charcoal

144 *Antelope* 1982 21.6 × 27.9cm etching, edition of 65 + 15

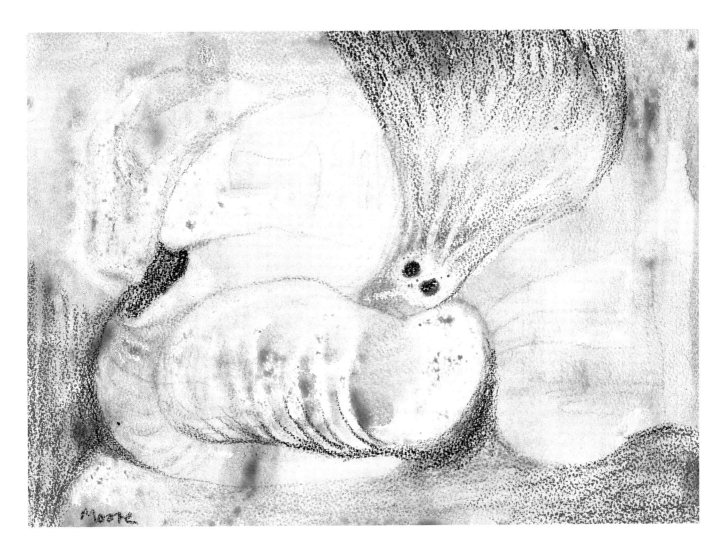

XIX *Swooping Bird* 1982 25.3 × 35.4cm crayon, watercolour wash,
charcoal, crayon

'You can make a grotesque out of anything.'

Henry Moore with the elephant skull and *Maquette for Atom Piece.*

'All the time that I am doing this small model, in my mind it isn't the small model that I'm doing, it's the big sculpture that I intend to do.'

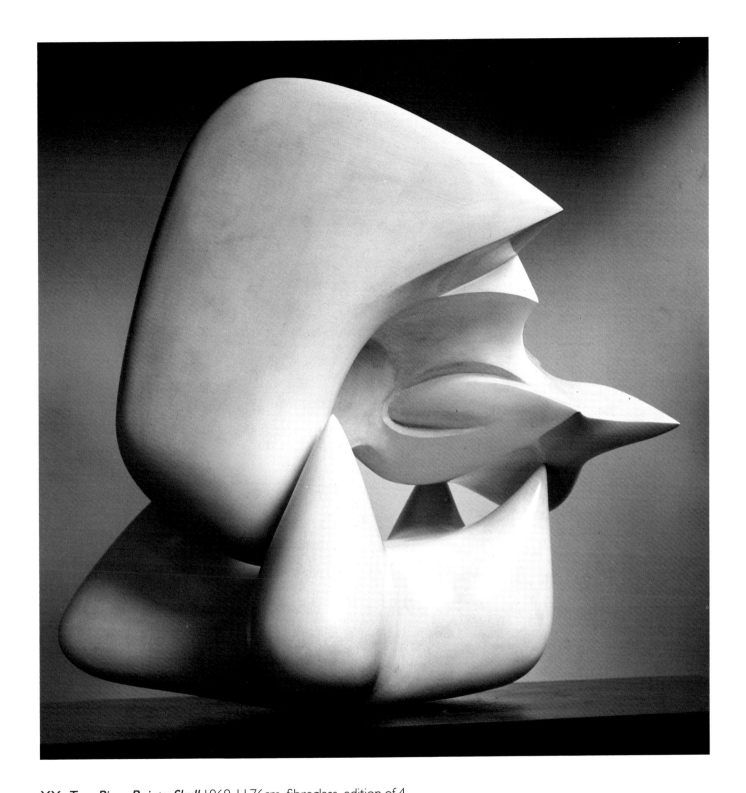

XX *Two Piece Points: Skull* 1969 H 76cm fibreglass, edition of 4

A striking transformation: the main features of the skull have been
resolved into a bold synthesis of form.

XXI *Elephant* 1982 23.6 × 25.2 cm charcoal, wax crayon, watercolour
wash, ballpoint pen, chalk

The essence of power, to which a mischievous eye gives animation.

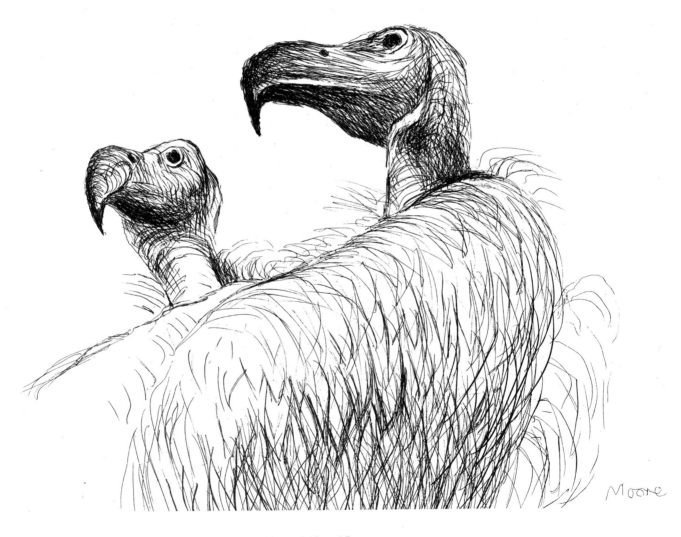

145 *Vultures* 1981 21.6 × 27.9cm etching, edition of 65 + 15

146 *Zebra* 1979 21.5 × 27.9cm carbon line, crayon, conté crayon

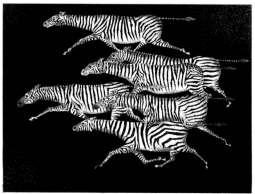

Six Zèbres courant Mario Avati, 1960, aquatint

Moore

147 *Dromedary* 1981 21.6 × 27.9cm etching, edition of 65 + 15

148 *Dromedary* 1979 19.9 × 27.8cm ballpoint pen, charcoal

Moore

149 *Bison* 1981 21.6 × 27.9cm etching, edition of 65 + 15

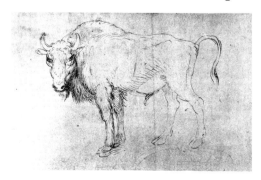

Bison Albrecht Dürer (undated)
pen and ink

150 *Bison* 1979 21.5 × 27.9cm carbon line, watercolour, conté crayon, ballpoint pen, gouache, charcoal

151 *Bison in profile* 1979 19.4 × 28.5cm charcoal, conté crayon, gouache, ballpoint pen

152 *Rhinoceros* 1982 20.9 × 28.8cm charcoal, ballpoint pen

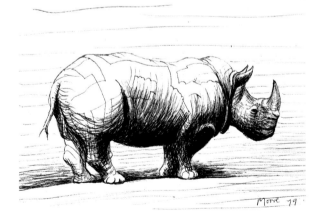

153 *Rhinoceros* 1979 19.9 × 27.8cm ballpoint
pen, charcoal

162

Rhinoceros Albrecht Dürer, 1515,
woodcut

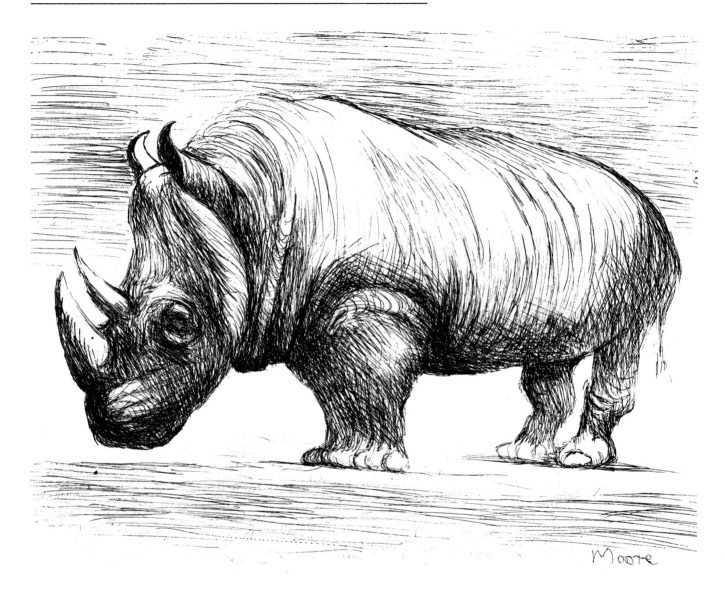

154 *Rhinoceros* 1981 21.6 × 27.9cm etching, edition of 65 + 15

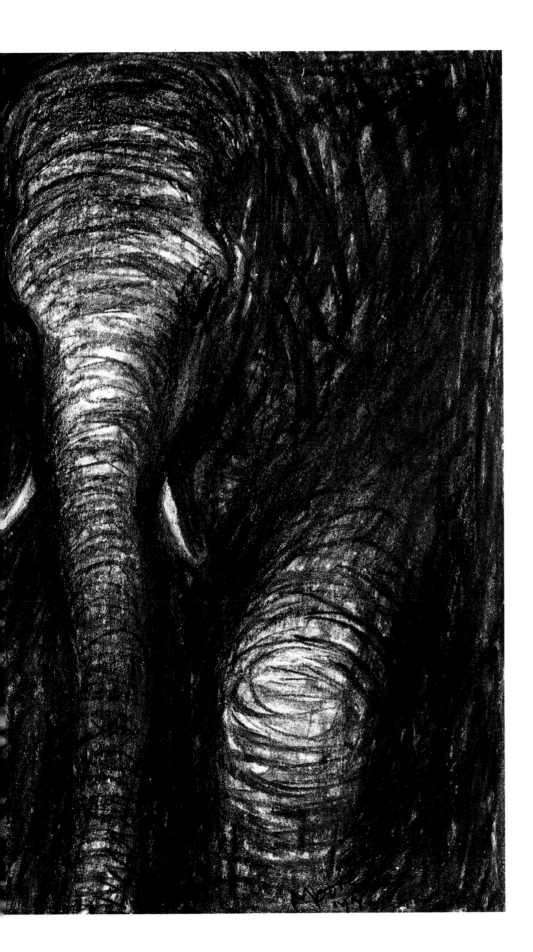

155 *Forest Elephants* 1977
30.7 × 38.6cm charcoal, chalk

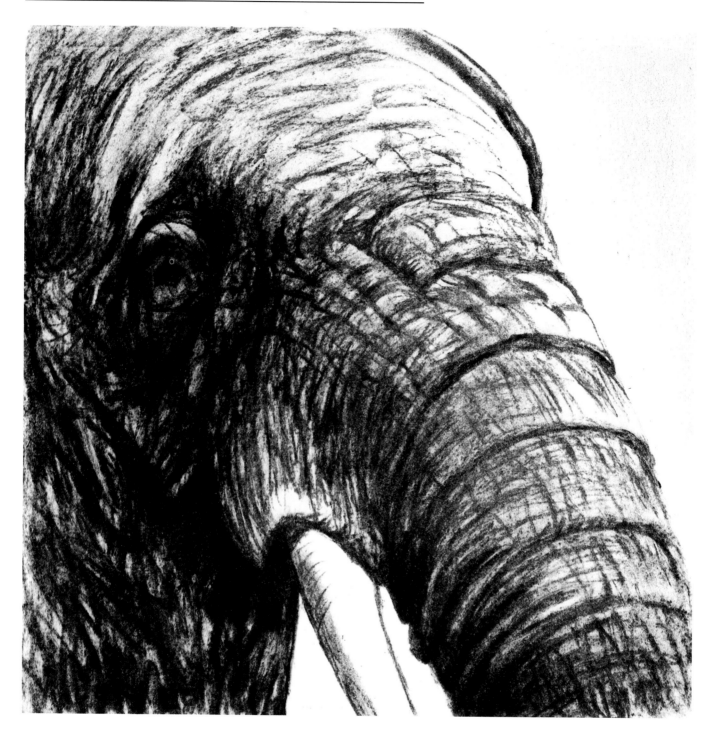

156 *Elephant's Head II* 1981 23.2 × 23.2cm lithograph in three colours, edition of 50 + 15

157 *Elephant* 1981 27.9 × 35.6cm etching, edition of 15 + 10

Elephant Rembrandt, *c.* 1637, black chalk

SELECTED BIBLIOGRAPHY

Henry Moore: Sculpture and Drawings 4 vols (Lund Humpries, 1944–77)

Henry Moore: Catalogue of Graphic Work 3 vols (Cramer, Geneva, 1973–80)

Henry Moore: unpublished drawings, David Mitchinson (Pozzo, Milan; Abrams, New York, 1971)

Henry Moore Early Carvings, a catalogue with three essays (Leeds City Art Gallery, 1982)

Henry Moore's Sheep Sketchbook (facsimile) Comments by Henry Moore and Kenneth Clark (Thames & Hudson, 1980)

Henry Moore, John Hedgecoe (Thomas Nelson, 1968)

Henry Moore Drawings, Kenneth Clark (Thames & Hudson, 1974, London; Harper & Row, New York)

Henry Moore at the British Museum (British Museum Publications, 1981)

Works by the author on aspects of Henry Moore's sculpture and graphic work:

Towards Sculpture (Thames & Hudson, 1976)

Open Air Sculpture in Britain (The Tate and A. Zwemmer Ltd, in preparation)

Articles:

'Henry Moore's Prométhée', *Image*, No. 8 (1952)

'Henry Moore's Unesco Sculpture', *Studio* (Dec. 1958)

'Sheep in Sketch and Sculpture', *The Countryman* (spring 1975)

'Henry Moore's Stonehenge', *The Countryman* (spring 1977)

'Henry Moore: The Man and His Work', *Blackwood's Magazine* (July 1978)

General works consulted:

Animals in Art, Jessica Rawson (British Museum Publications, 1977)

Animals and Men, Kenneth Clark (British Museum Publications, 1977)

The Painter's Object, various authors and artists including Henry Moore (Gerald Howe Ltd, 1937)

LIST OF PLATES

Works by Henry Moore

1 *Snake* 1924 H 15.2cm marble The Artist
2 *Drawing for Marble Snake* 1924: detail of page 81 from No 2 Notebook 1921/22
22.5 × 17.2cm pen and ink
3, 4, *Head of Serpent* 1927 H 20.3cm stone
5 *Snake Head* 1961 H 10.2cm bronze, edition of 6
6, 7 *Serpent* 1973 L 24cm bronze, edition of 9
8 *Slow Form: Tortoise* 1962 L 21.6cm bronze, edition of 9
9 *Large Slow Form* 1962–8 L 77cm bronze, edition of 9
10 *Bird Table* 1954 H 1.5m terracotta The Henry Moore Foundation
11 *Sketch based on negro artefact*: detail of page 102 from No 3 Notebook 1922/24
22.5 × 17.2cm pencil
12 *Bird Basket* 1939 L 41.9cm lignum vitae and string Mrs Irina Moore
13 *Copy of upper portion of an Inca pot from Chimbote*: detail of page 101 from No 3
Notebook 1922/24 22.5 × 17.2cm pencil and chalk
14 *Heads of Animals*: detail of page 82 from No 2 Notebook 1921/22 22.5 × 17.2cm
pen and ink, chalk
15, 16 *Bird* 1927 H 22.8cm approx bronze cast Private collection
17 *Duck* 1927 H 15.2cm concrete Private collection
18 *Idea for Sculpture*: detail of page 34 from No 2 Notebook 1921/22 22.5 × 17.2cm
pencil
19 *Bird and Egg* 1934 L 55.9cm Cumberland alabaster Private collection
20 *Object: Bird Form* 1955 L 10.2cm bronze, edition of 9
21 *Bird* 1955 L 14cm bronze, edition of 12
22 *Birds: Three Crows* 1951: page 63 from Sketchbook 1950/51 18.8 × 21.6cm
pencil Marlborough Fine Art, London
23 *Bird* 1959 L 38.1cm bronze, edition of 12
24 *Bird feeding young bird*: detail of page 84 from No 2 Notebook 1921/22
22.5 × 17.2cm pen and ink
25 *Fledgling* 1960 L 17.8cm bronze, edition of 9
26 *Fledglings* 1971 L 16cm bronze, edition of 12
27 *Bird Form II* 1973 L 40cm black marble
28 *Bird Form I* 1973 L 37cm black marble
29 *Owl* 1966 H 20cm bronze, edition of 5
30 *Helmet Head No 2* 1950 (detail) H 34.3cm bronze, edition of 9
31 *Three Part Object* 1960 H 1.2m bronze, edition of 9
32 *Divided Oval: Butterfly* 1967, cast 1982 L 91cm bronze The Henry Moore
Foundation (A large bronze version of this sculpture is currently being cast)
33 *Divided Oval: Butterfly* 1967 L 91cm white marble Sutton Place
34 *Butterfly Form* 1976 L 16.5cm bronze, edition of 7
35, 36, 37 *Butterfly* 1977 L 47cm marble Private collection
38 *Circus Rider* 1979: tapestry woven at West Dean College (The Edward James
Foundation) from a drawing of 1975 2 × 1.7m Private collection
39 *Ideas for Animal Sculpture*: page 55 from No 2 Notebook 1921/22 22.5 × 17.2cm
pencil
40 *Study after Scythian Horse* (undated) 21 × 29.8cm charcoal The Henry Moore
Foundation
41 *Idea for Sculpture: Horse* c. 1922 9.5 × 15.2cm pen and ink
42 *Horse* 1923 H 10.2cm bronze, edition of 3
43 *Animal: Horse* 1960, cast 1965 H 17.8cm bronze, edition of 6
44 *Rearing Horse* 1959, cast 1972 H 20cm bronze, edition of 9
45 *Horse* 1959 H 19cm bronze, edition of 2

46 *Studies after a Trecento Italian painting:* page 189 from No 3 Notebook 1922/24 22.5 × 17.2cm pencil

47 *Circus Rider* 1979: detail of tapestry (38)

48 *Horse and Rider* 1982 17.6 × 19.4cm ballpoint pen, crayon, watercolour wash, gouache The Henry Moore Foundation

49 *Animal Studies* 1950 29.2 × 23.8cm pencil Private collection

50 *Boy and Pony:* page from Coalmine Sketchbook 1942 25.1 × 17.8cm chalk, crayon, watercolour wash

51 *Horses at the Circus:* page from Sketchbook 1955/56 29.2 × 24.2cm pen and ink

52 *Horses' Heads* 1981: Study after Lorenzo Ghiberti, David – panel 9 from 2nd baptistery doors (*Porta del Paradiso*) 10.8 × 25.4cm soft pencil, charcoal The Henry Moore Foundation

53 *Three Sisters* 1981 35.3 × 25.1 lithograph in eight colours, edition of 50 + 15

54 *Goat's Head* 1952 H 20.3cm plaster

55 *Goats:* page 131 from Sketchbook 1921 17.2 × 22.2cm pen and ink Private collection

56 *Goats:* page 128 from Sketchbook 1921 17.2 × 22.2cm pen and ink The Henry Moore Foundation

57 *Sheep with Lamb I:* page 15 from Sheep Sketchbook 1972 21 × 25.1cm ballpoint pen, crayon, wash Private collection

58 *Shorn Sheep:* page 47 from Sheep Sketchbook 1972 21 × 25.1cm ballpoint pen Private collection

59 *Sheep after Shearing* 1982 20.9 × 24.4cm charcoal, felt-tip pen, gouache The Henry Moore Foundation

60 *Sheep:* page 91 from No 2 Notebook 1921/22 22.5 × 17.2cm pencil, pen and ink The Henry Moore Foundation

61 *Sheep in Field:* page 14 from Sheep Sketchbook 1972 21 × 25.1cm ballpoint pen, wash Private collection

62 *Sheep before Shearing* 1974 20 × 28.2cm lithograph in two colours, edition of 50 + 15

63 *Head:* page 45 from Sheep Sketchbook 1972 21 × 25.1cm ballpoint pen Private collection

64 *Sheep:* page 38 from Sheep Sketchbook 1972 21 × 25.1cm ballpoint pen Private collection

65 *Sheep with Lamb II* 1972 14.9 × 20.6cm etching and dry point, edition of 80 + 15

66 *Sheep Climbing* 1974 17.2 × 19.7cm lithograph in one colour, edition of 30 + 10

67 *Sheep Back View* 1972 21.3 × 18.8cm etching, edition of 80 + 15

68 *Sheep* 1960, cast 1968 L 24cm bronze, edition of 9

69 *Projects for Hill Sculpture* 1969 (detail) 30.8 × 24.1cm etching, edition of 100 × 35

70 *Maquette for Sheep Piece* 1969, cast 1974 L 14cm bronze, edition of 7

71, 73 *Sheep Piece* 1971–2 H 5.7m bronze, edition of 3

72 *Working Model for Sheep Piece* 1971 L 1.4m bronze, edition of 9

74 *Animal Studies* 1950 29.2 × 23.2cm pencil Private collection

75 *Cow:* fragment page from Sketchbook 1921 12.1 × 14.7cm pencil, pen and ink The Henry Moore Foundation

76 *Cow* 1981 17.6 × 25.3cm pen and ink, crayon, charcoal, watercolour wash, chinagraph, ballpoint pen, gouache The Henry Moore Foundation

77 *Dog with Bone:* detail of page 126 from No 3 Notebook 1922/24 22.5 × 17.2cm pencil

78 *The Dog Fight:* detail of page 31 from No 6 Notebook 1926 22.5 × 16.8cm pen and ink The Henry Moore Foundation

79 *Dog* 1922 H 17.8cm marble The Henry Moore Foundation

80 *Dog's Head* 1980 L 12.1cm bronze, edition of 9

81 *Woman holding cat* 1949 29.8 × 48.9cm collograph in four colours, edition of 75

122 *Head and Forequarters of Lynx* 1982 25.4 × 19.9cm charcoal The Henry Moore Foundation

123 *Study after Lynx* 1982 17.7 × 25.4cm carbon line, charcoal, ballpoint pen The Henry Moore Foundation

124 *Square Form Lyre Birds* 1936 (redrawn 1942 and 1973): page from Sketchbook with Square Forms and Lyre Birds 25.7 × 17.8cm chalks, wash, coloured ink The Henry Moore Foundation

125 *Animal Head:* detail of page 45 from Sketchbook 'B' 1935 21.6 × 14cm pencil, chalk The Henry Moore Foundation

126 *Bird Head* 1934 27.3 × 37.5cm pen and ink, chalk, wash Private collection

127 *Man holding rabbit* 1954 16.5 × 13.3cm pen and ink

128 *Headless Animal* 1960 L 24.1cm bronze, edition of 6

129 *Animal* 1975 L 19cm bronze, edition of 7

130 *Three Quarter Figure* 1961 H 38.1cm bronze, edition of 9

131 *Centaurs* 1954 29.2 × 24.1cm pencil The Henry Moore Foundation

132 *Fabulous Animals* 1950 29.2 × 24.2cm chalk, crayon, watercolour

133 *Girl playing piano: Head and Dog* 1942 22.2 × 16.5cm crayon, wash Private collection

134 *Detail of inside cover page from No 6 Notebook* 1926 22.5 × 16.8cm pencil The Henry Moore Foundation

135 *Animal Head* 1980 25.2 × 35.5cm wash, charcoal, wax crayon, gouache, felt-tip pen Galerie Bayeler, Basle

136 *Racehorse* 1982 17.6 × 25.4cm stabilo pen, gouache The Henry Moore Foundation

137 *Leaping Lamb* 1982 18.5 × 22.9cm ballpoint pen The Henry Moore Foundation

138 *Animals* 1981 21.5 × 37.9cm ballpoint The Henry Moore Foundation

139 *Animals and man climbing a ladder* 1981 27.9 × 29.4cm ballpoint pen The Henry Moore Foundation

140 *Leopard* 1982 25.4 × 19.7cm etching and aquatint, edition of 65 + 15

141 *Tiger* 1982 19.4 × 24.1cm etching, edition of 65 + 15

142 *Tiger* 1982 25.5 × 35.5cm charcoal The Henry Moore Foundation

143 *Tiger* 1982 12.7 × 10.2cm etching, edition of 50 + 20

144 *Antelope* 1982 21.6 × 27.9cm etching, edition of 65 + 15

145 *Vultures* 1981 21.6 × 27.9cm etching, edition of 65 + 15

146 *Zebra* 1979 21.5 × 27.9cm carbon line, crayon, conté crayon Private collection

147 *Dromedary* 1981 21.6 × 27.9cm etching, edition of 65 + 15

148 *Dromedary* 1979 19.9 × 27.8cm ballpoint pen, charcoal Private collection

149 *Bison* 1981 21.6 × 27.9cm etching, edition of 65 + 15

150 *Bison* 1979 21.5 × 27.9cm carbon line, watercolour, conté crayon, ballpoint pen, gouache, charcoal Private collection

151 *Bison in profile* 1979 19.4 × 28.5cm charcoal, conté crayon, gouache, ballpoint pen The Henry Moore Foundation

152 *Rhinoceros* 1982 20.9 × 28.8cm charcoal, ballpoint pen The Henry Moore Foundation

153 *Rhinoceros* 1979 19.9 × 27.8cm ballpoint pen, charcoal Private collection

154 *Rhinoceros* 1981 21.6 × 27.9cm etching, edition of 65 + 15

155 *Forest Elephants* 1977 30.7 × 38.6cm charcoal, chalk The Henry Moore Foundation

156 *Elephant's Head II* 1981 23.2 × 23.2cm lithograph in three colours, edition of 50 + 15

157 *Elephant* 1981 27.9 × 35.6cm etching, edition of 15 + 10

INDEX